Fascinating Coons

AMAZING IMAGES & BEHAVIORS

BY STAN TEKIELA

Adventure Publications, Inc.
Cambridge, MN

DEDICATION

Dedicated to William (Buck) Huber, a man whose love for loons and photography helped inspire this book.

ACKNOWLEDGMENTS

I would like to thank technical editor Jim Paruk, Ph.D., Professor of Biology, Northland College, Ashland, Wisconsin, whose extensive knowledge of loons significantly contributed to the accuracy of this book.

Cover photo by Stan Tekiela: Common Loon family at sunset on Lake Sylvia, Wright County, Minnesota

Photos by Stan Tekiela

Edited by Sandy Livoti

Book design by Jonathan Norberg

TABLE OF CONTENTS

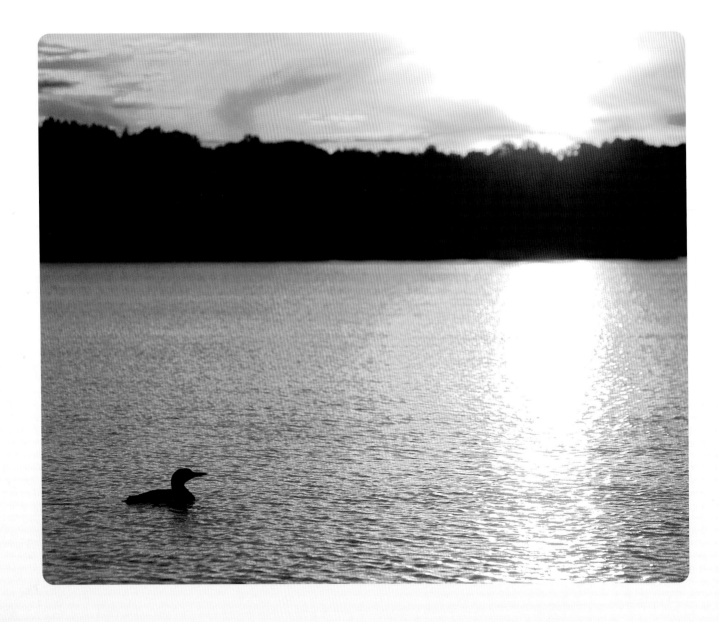

As a professional naturalist and wildlife photographer, I often spend days, weeks or sometimes months observing, studying and photographing a subject—and the loons in this book are no exception. In these pages you will find images that took me over 3 years to gather. Many of the behaviors described in the text I personally witnessed and photographed. As much as I enjoyed researching, writing and photographing, I hope you'll enjoy this book about the fascinating loons of the Northwoods even more.

Enjoy the Loons!

Stan Tekiela

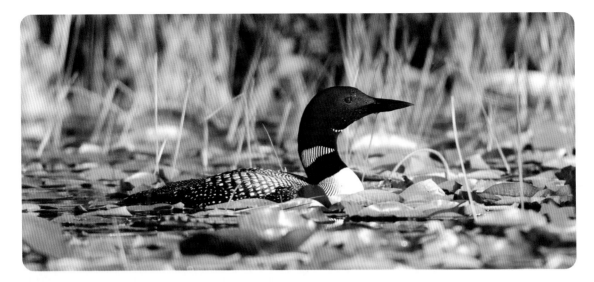

FASCINATING LOONS

Loons have fascinated people for thousands of years. The striking black-and-white breeding plumage and deep red eyes of the Common Loon befit its elegance and grace. Loons are physically amazing, with large, powerful feet that propel the bird underwater at speeds fast enough to overtake fish. They have wings capable of carrying them thousands of miles to wintering grounds and back again with the changes of the seasons. The call of the loon catapults our memories to a time spent camping or brings to mind a lakeside summer vacation. Yes, loons have fascinated people for thousands of years–just as they do today. Here is the story of the Common Loon.

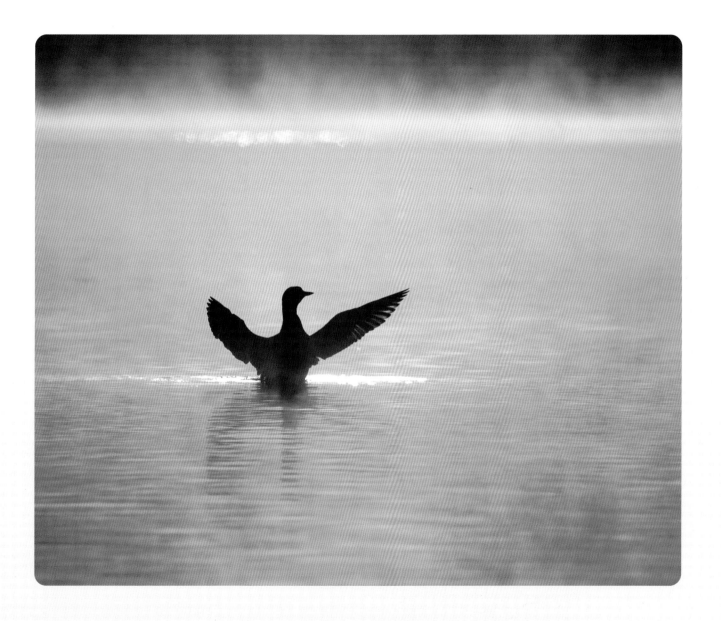

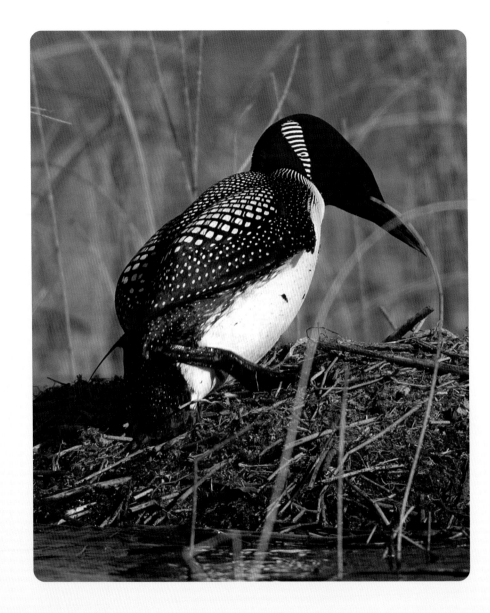

Several native cultures tell stories of how the loon was created. According to one, the loon and the crow were once men. They were good friends and did everything together. One day they decided to go fishing. One of the men caught lots of fish. The other man caught none. The man who had no fish became so upset that he hit his friend, cut out his tongue and threw him overboard. The Great Spirit felt sorry for the beaten man and turned him into a beautiful loon, while his friend was turned into a crow.

A story from Finnish culture tells us when the first loon was created, it didn't have legs or feet. Nature realized its mistake and flung a pair of legs and feet at the bird as it was leaving, which is why the legs and feet are located so far back on the loon's body.

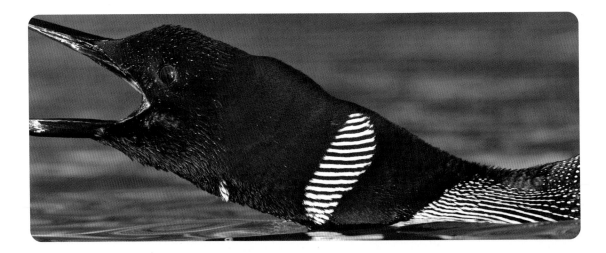

FOLKLORE OF THE NECKLACE

Loons have played a part in the lives of native peoples around the world. Many ancient cultures had stories and myths about loons. There are various folktales about loons restoring sight to blind children or healing the failed sight of medicine men. Legend has it that a loon would carry an afflicted person on its back to the bottom of a lake, once, twice, again and again until enough water washed over the person's eyes to restore the eyesight. It has been said that a grateful person made the loon a gift of thanks—a necklace of white shells—and hung it around the loon's neck for all to see. To this day, all loons wear a necklace of white plumage resembling the strand of white shells given in gratitude long ago.

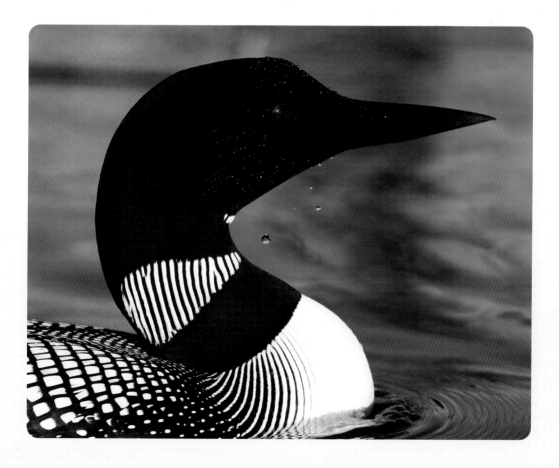

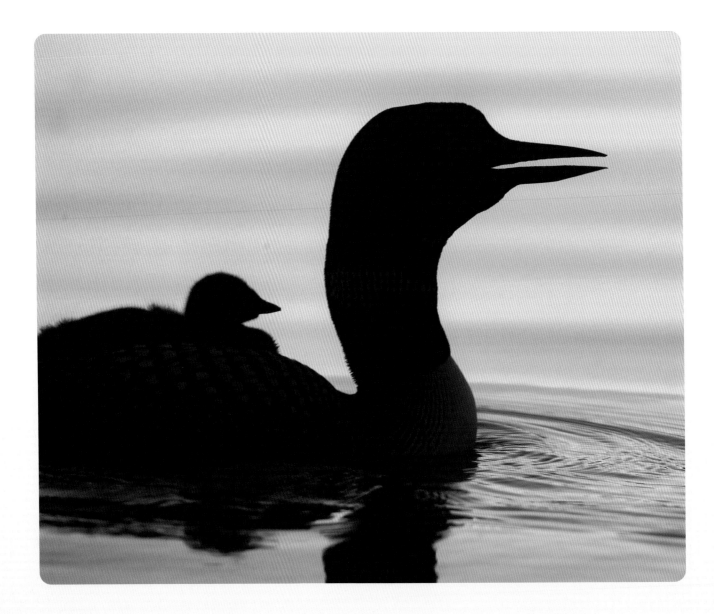

A story about the loon's call comes from Micmac Indian culture. A man named Glooscap came to visit the Micmac tribe one day. The people enjoyed his company so much, they did not want him to leave. Even so, after a few days he had to move on. Because the Micmacs were so lonely, Glooscap appointed Kwee-moo, the loon, as his special messenger. Glooscap said he would return whenever the loon called because his call could be heard from far away. Today we call that special call the wail of the loon.

Down through history it was thought loons could predict the coming of rain. Some cultures believed the call of a loon triggered rain. These notions are why the loon is also called Rain Crow.

More recently, the peculiar laughing call of the loon led to the phrase "crazy as a loon."

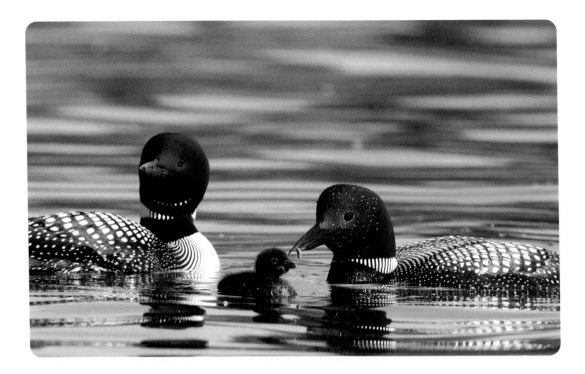

THE FIVE SPECIES OF LOONS

Loons are in their own order, the Gaviiformes. The loon
family, called Gaviidae, comprises five species. Each species
can be found in North America–Common Loon (*Gavia
immer*), Yellow-billed Loon (*G. adamsii*), Red-throated Loon
(*G. stellata*), Pacific Loon (*G. pacifica*) and Arctic Loon (*G. arc-
tica*). All nest in Alaska, and all but the Arctic Loon nest in
Canada. The Common Loon is the only species that nests in
the lower 48 states. Loons are closely related to grebes.

In 1758, Linnaeus, the father of the genus and species nam-
ing systems, gave loons and grebes one genus name,
Colymbus, from the Greek word *kalymbis*, meaning "diving
bird." The British insisted on calling the genus *Colymbus*,
while the Americans wanted separate names to reflect the
differences between loons and grebes. The dispute was
resolved in 1789 when the International Commission of
Zoological Nomenclature abolished the name *Colymbus* and
called the loon genus *Gavia*, Latin for "aquatic bird," credit-
ing the name to German naturalist Johann Reinhold Forster.
Forster traveled around the world with Captain James Cook
in the 1700s and recorded many species including the loon.

The species name of the Common Loon, *immer*, is from the
Latin *immergo*, meaning "to immerse" or "to submerge."

The common name "Loon" is thought to have originated with early European settlers in North America and is based on an old Scandinavian word *lom*, meaning "lame" or "clumsy," referring to its awkward movement on land.

The French name for the loon, *plongeon*, translates to "diver." In most parts of the world, the loon is called Diver, Hell-diver or Great Northern Diver for its ability to dive to great depths akin to hell.

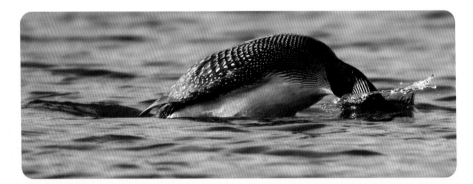

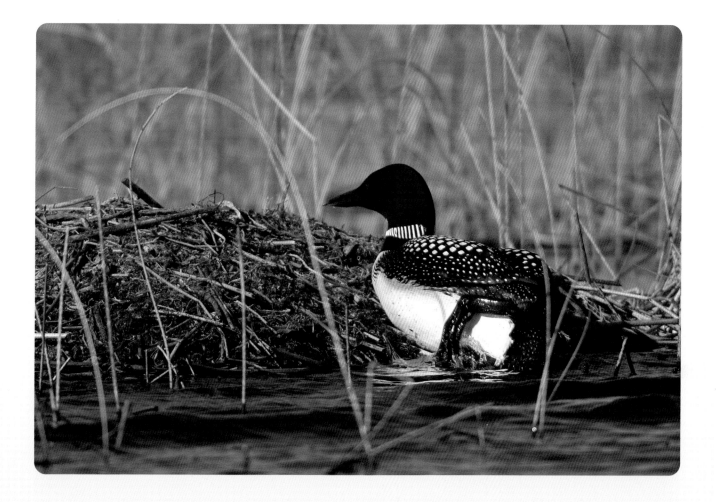

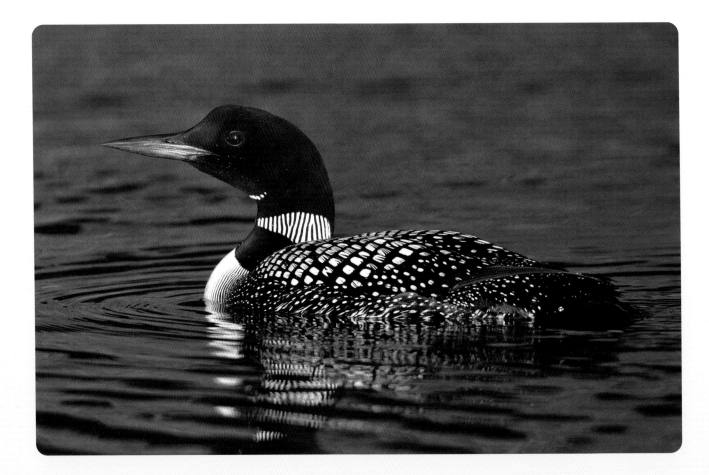

POPULAR NAMES AROUND THE WORLD

Popular common names for the Common Loon include Big Loon, Black-billed Loon and Ring-necked Loon. In Great Britain it is also called Walloon, Immer Goose, Ember Diver and Greenhead. In Norway and Sweden it was called Islom or Ice Loon.

An old, but popular name for the Common Loon in northern Europe is Ember Goose, which relates to its species name *immer*. The legend of the Ember Goose describes how the loon got its distinctive coloration–by being doused with ashes and embers.

Loons are often referred to as feathered fish because they spend so much of their life underwater or on the surface of the water. They touch land only at birth, during mating and while nesting.

In the mid-twentieth century it was believed loons could survive only on clear wilderness lakes without human disturbance. The idea that loons need wilderness has now been disproved. The limiting factor in loon habitat is not the presence of people, but rather the availability of safe nesting locations undisturbed by people and free from predators such as raccoons and skunks. In addition they need clear water since loons hunt by eyesight, and the availability of small and large fish.

The range of the Common Loon in North America spans most of Alaska to across Canada and south to many northern tier states such as Minnesota, Wisconsin, Michigan, New York, Vermont, New Hampshire and Maine. While loons nest mainly in North America, small populations also breed in Greenland and Iceland. Many Common Loons winter in northern Europe and the British Isles.

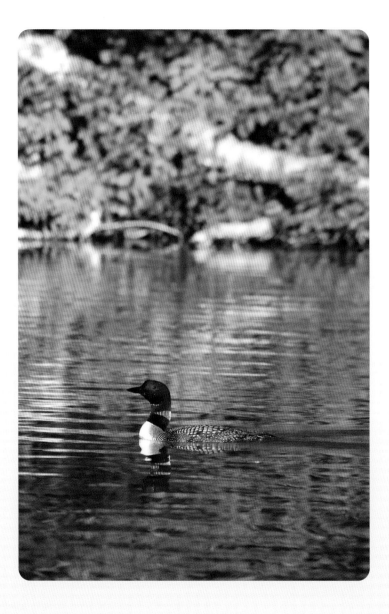

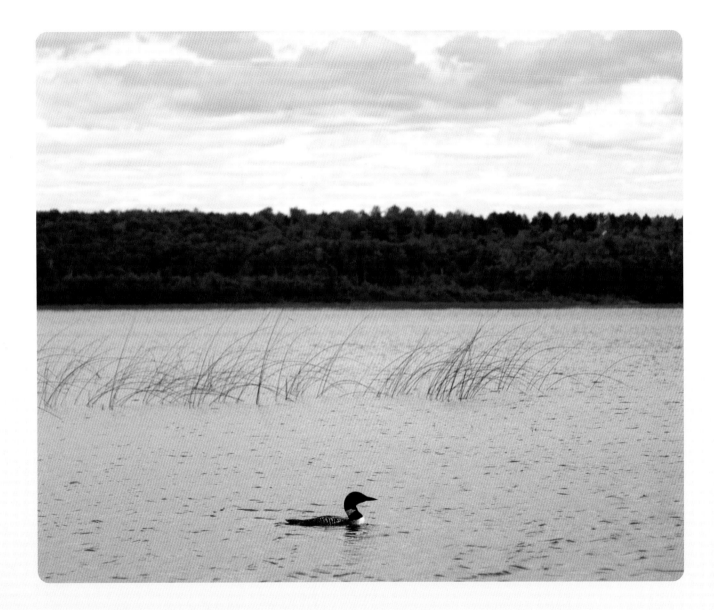

GENERAL POPULATION

With its nearly 13,000 large lakes and hundreds of thousands of small lakes, Minnesota has more loons than any other state in the continental U.S.–about 12,000 individuals. Maine is next, with approximately 5,000 loons. The rest of the states have stable or growing populations.

Only 1–2 pairs of loons occupy an area of about 2 square miles (5.2 sq. km). The resident loons defend their territory against all other loons, thus keeping the population density down. Some people think populations of loons should be controlled because of the amount of fish they eat. This is an argument that focuses too much on human desires and not on what is needed to maintain a healthy ecosystem that includes loons.

THE DECLINE OF THE LOON

Loons once nested as far south as Iowa, Illinois and Pennsylvania. They were at their lowest population and most limited range during the 1970s. The reduction was, in part, due to destruction of habitat including increased human disturbance during nesting, chemicals in the environment and water pollution. The expansion of birds such as Ring-billed Gulls, which feed on loon eggs and very young loons, has also played a role in the decline of the loon.

HUMAN DISTURBANCE AND NEST FAILURE

It is often thought that loons need wilderness lakes to nest. I have observed loons successfully nesting and raising their young on lakes lined shoulder-to-shoulder with year-round homes and summer cabins. Loons can nest and raise young on lakes with a high density of human dwellings and a high degree of recreational activity. Some places have heavy boat traffic (especially on weekends), jet skiing and legions of fishermen. At these areas, loons navigate among water-skiers, fishermen and recreational boaters, usually without major incident. While it may not be an ideal place for loons, it appears that they can successfully reproduce on these lakes.

However, having said that, human disturbance is still the number one reason for the decline of the loon, now and in the past. Loss of nesting sites, disturbance during nesting by roaming domestic dogs and cats, and especially waves from powerboats and jet skis washing over nests and eggs are just a sampling of causes of nest failure.

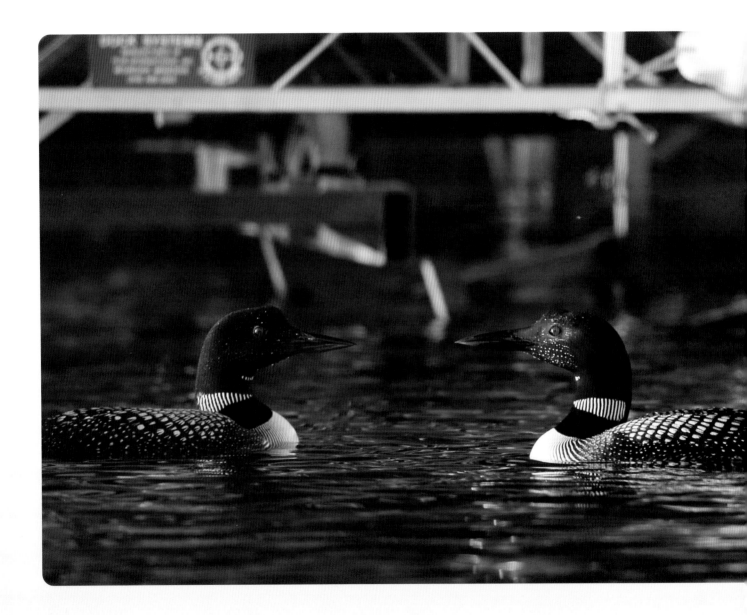

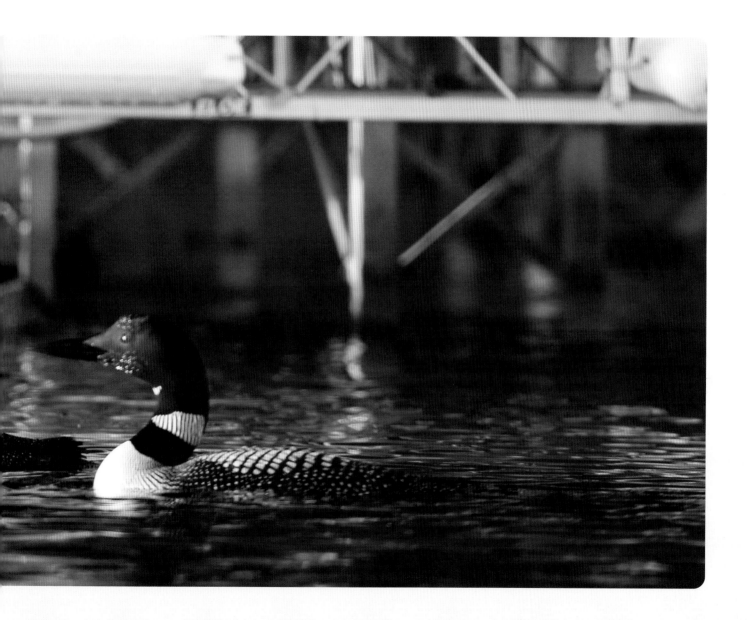

LEAD SINKERS

Lead in the form of fishing sinkers is the leading cause of adult loon mortality. One study showed that 52 percent of autopsied loons died from acute lead poisoning. Loons swallow lead sinkers when they ingest small stones (grit) at the bottom of lakes. Split shot sinkers are the perfect size and shape for loons to confuse with grit, which aids digestion. After ingestion, a loon will start showing symptoms in only a few days. Once the bird has reached this point, the mortality rate is nearly 100 percent. Just a single split shot sinker can kill a loon.

FISHING LINE

Discarded monofilament fishing line is another danger to loons. Contact with discarded line results in entangled wings, which renders a loon flightless, to bills tied shut, causing a slow, starving death. In many areas, entanglement in fishing line is the second common cause of death in loons.

Loons also have a high mortality rate during winter. Loons spend the winter on coastal waters, where they are exposed to many hazards such as oil spills in addition to recreational boating. Entanglement in commercial fishing nets is a major problem for loons. It seems no matter where they go, contact with people is a constant threat.

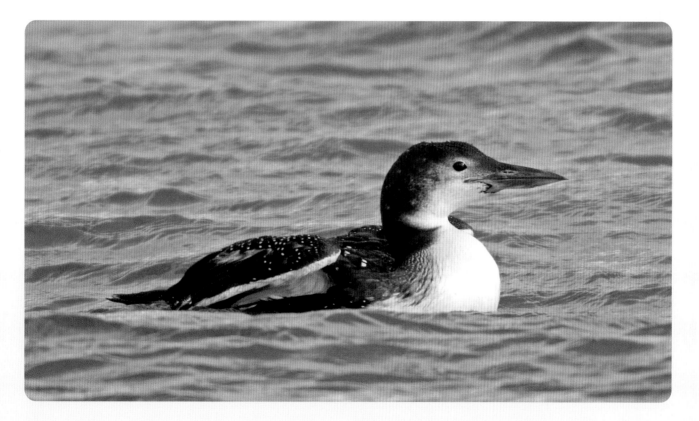

Mercury in the environment is also a problem for loons. Mercury poisoning affects the nervous system, impairing vision and coordination. With reduced abilities to catch fish, loons quickly become weak and die.

A survey sampling loons in the Great Lakes region showed about 5-10 percent and some New England states showed about 20 percent of the loons had low mercury levels, but even low levels of mercury reduce reproduction success. Loon observers have noted an increase in the number of adult loons, but fewer chicks hatching–which may be an indication of mercury poisoning. Since loons are long-lived birds, a short disruption of breeding can be tolerated. Long-term reproduction failures will lead to the demise of the bird, as it nearly did during the middle of the last century when loons were affected by the insecticide DDT.

SICK OR INJURED LOONS

Sick or injured loons are often found on land. For whatever reason, when a loon feels ill or is injured it tends to gravitate toward land. Land-bound loons should be reported to a local wildlife rehabilitator or wild animal clinic.

Great care must be taken when trying to "rescue" a loon since its large heavy bill can inflict serious damage to the human body. It is best to leave the job of picking up a loon to someone who is experienced with these circumstances.

With a better understanding and respect for loons, the future for loons is promising. We have come a long way since the 1960-70s, when our water and air pollution was at its worst. Many birds such as loons were heavily contaminated with chemicals (DDT), heavy metals and more, causing a tremendous drop in population—the lowest ever for loons. The Endangered Species Act and Clean Water Act combined with widespread environmental education and sound scientific studies are making it possible for loons and other birds and animals to make remarkable recoveries. While it may not be possible for loons to return to their historic range, with proper guidelines and policy decisions, we can keep the loons we have for a long time to come.

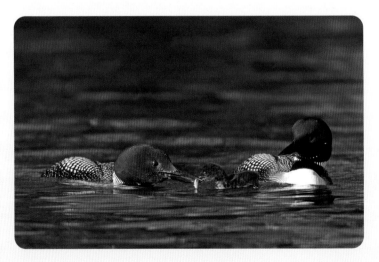

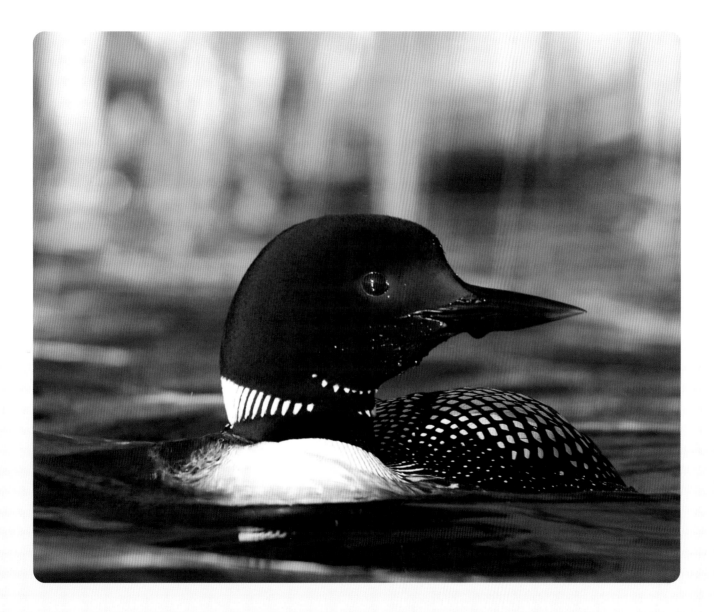

DIFFERENCES OF THE SEXES

Males are generally larger than females, up to 20 percent. Their heads are slightly larger and they have longer, heavier bills than females. However, no one trait can be used to accurately identify the sexes. It's very difficult to distinguish between male and female loons unless they are sitting side by side for comparison.

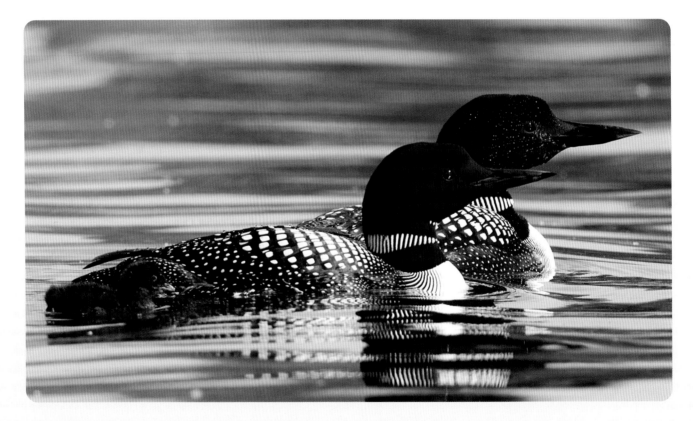

Adult loons have a 5-foot (1.5 m) wingspan and measure 3 feet (.9 m) from tip of bill to outstretched feet. Adult males weigh from 7-17 lb. (3.2-7.6 kg), while adult females weigh 5.5-14 lb. (2.5-6.3 kg). Loon chicks are only a few ounces when they hatch, but due to their high-protein diet of fish, they grow quickly and reach 6-8 pounds (2.7-3.6 kg) in just 3 months.

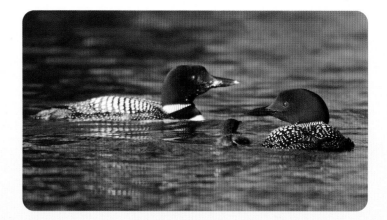

LIFE SPAN

Loons can live up to 30 years. The majority of deaths occur in the first 1-2 years of life. If a loon can make it to adulthood, it usually will live a long time and reproduce often enough to offset the high mortality rate of young birds.

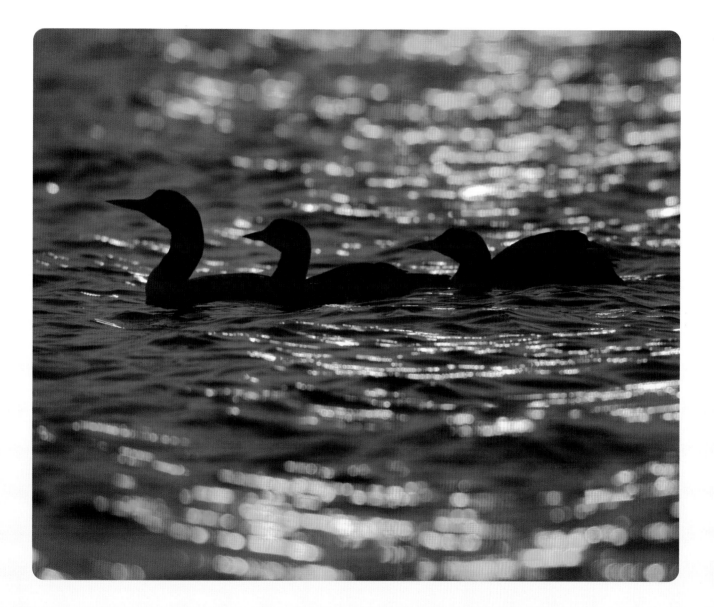

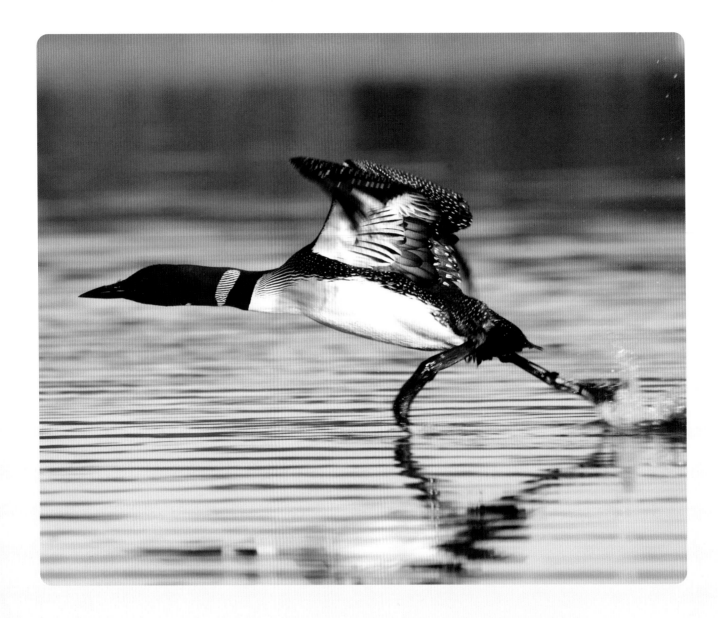

UNIQUE ALIGNMENT

A loon's skull is thicker and heavier than other birds that are similar. In addition, the skull articulates with the spinal column in a unique way, allowing the head and neck to extend straight out in front, thus making the loon very streamlined underwater and during flight.

BONES FOR SWIMMING AND DIVING

While most birds have hollow bones (pneumatic bones), loons have mostly solid bones (non-pneumatic bones), making them heavier than other birds of similar size. The added weight increases their specific gravity (neutral density), which makes their bodies ride lower in water and decreases the amount of energy needed to swim underwater, where they spend much of their time during the day.

BUILT-IN NOSE PLUGS

The nostrils have a flap or valve on the upper rim that is unique to loons. This closes during dives to keep water out and possibly helps maintain equal pressure during deep dives. It is believed that loons have a very reduced sense of smell, since flaps cover the nostrils while underwater and smell isn't needed to find fish underwater.

RED EYES

The adults of all five loon species have deep red eyes. The eyes are located in a forward position on either side of the head. The red eyes of the Common Loon contrast sharply against its stark black breeding head.

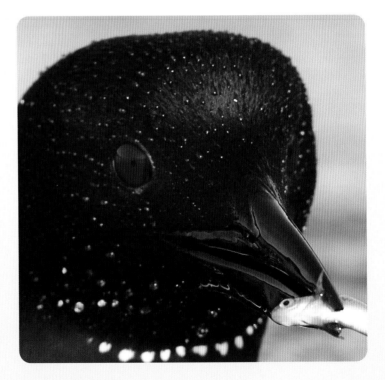

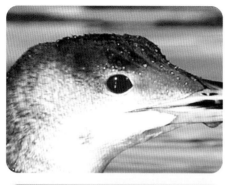

The eye color remains red during winter even though the plumage undergoes a drastic change from the bold black and white to a gray and white pattern.

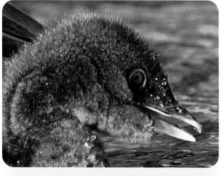

Chicks and juvenile loons have dull red-to-brown eyes. The eye color is yellow in young hawks such as the Cooper's Hawk and Sharp-shinned Hawk, then changes to deep red upon maturity at 3-4 years. The process is the same for loons. Their dull red eyes change to deep red by the time they reach adulthood at 3 years of age.

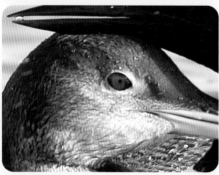

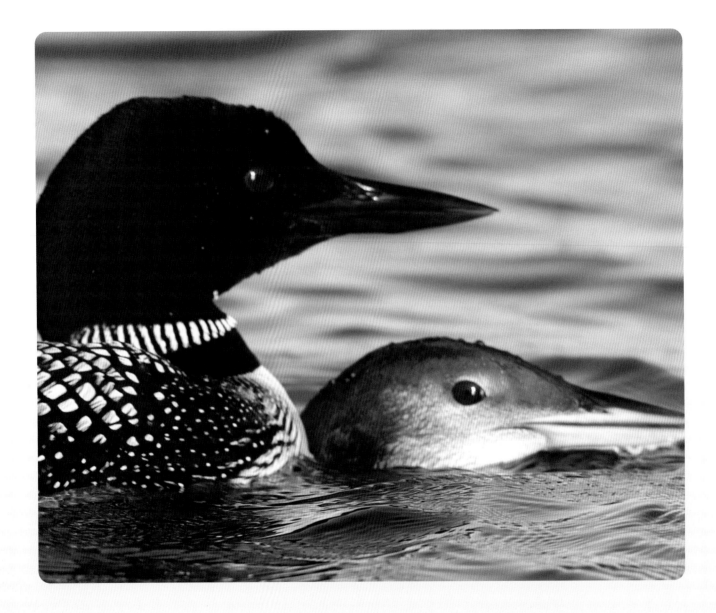

Not much is known about loon eyes, but ornithologists have shown that the color appears red in daylight because the eyes reflect the red part of the spectrum of sunlight while absorbing all the other wavelengths of light. However, due to the properties of water, most red light is filtered out, making the eyes appear black when underwater. Against the black head plumage, this may make the eyes invisible to prey and help camouflage the loon's presence.

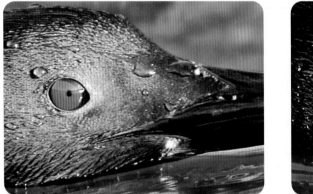

EXTRA EYELIDS

Like most birds, loons have an additional set of eyelids
known as a nictitating membrane that keeps the eyes clean
by blinking. Because the membrane is not clear (translucent),
some believe it may hinder vision. Others think it might act
as a sort of lens to actually aid in underwater vision.

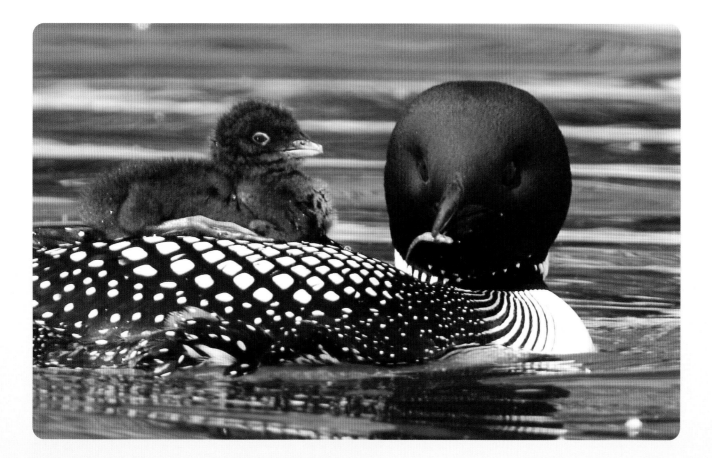

SEEING UNDERWATER

With eyes near the front of the head, loons have excellent stereoscopic vision, similar to our own. This allows good depth perception and helps them capture fish. Unlike humans, however, loons can see extremely well underwater.

POWERFUL LEGS

The legs and feet of a loon extend off to the sides of the body, similar to the oars of a rowboat. This allows one foot to propel and steer without interference from water turbulence created by the other foot.

The long leg bone (tibia) has an elongated bony spur called the cnemial crest, which increases the area of attachment to an enlarged thigh muscle, making it possible for loons to give powerful kicks.

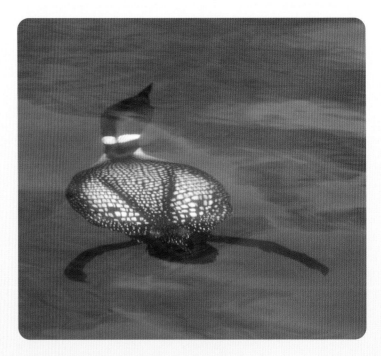

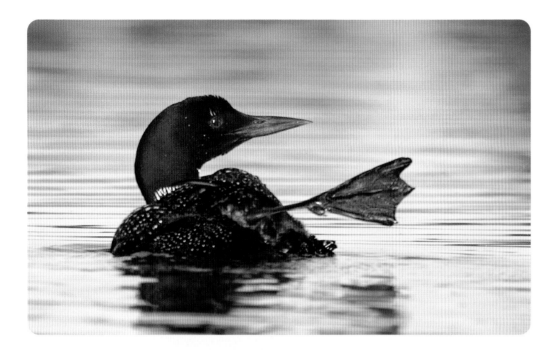

Loons have large webbed feet that propel them and produce great thrust. When a foot is drawn forward to begin a new stroke after kicking, the web collapses to reduce resistance and maintain speed.

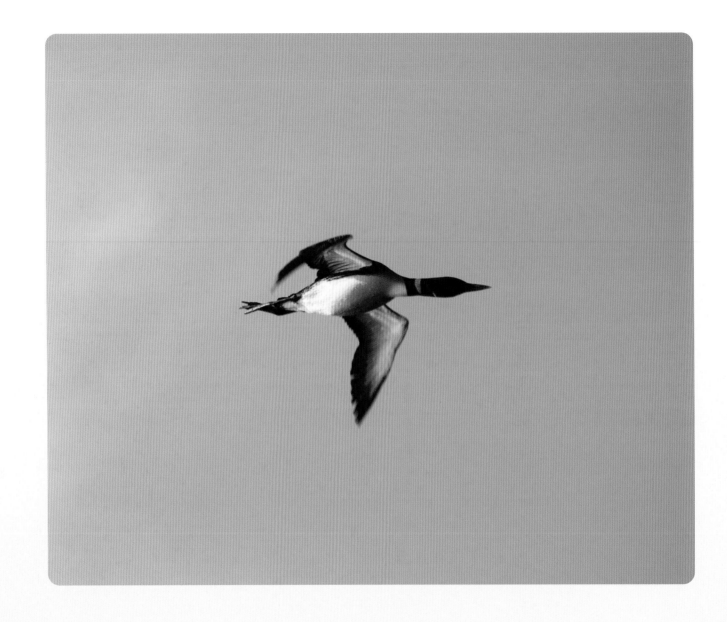

The exceptionally long wings of loons are positioned about halfway along the body, with equal weight in front and behind the wings.

The bodies of loons are heavier than other birds of similar size. Due to the extra weight, loon wings have more camber, or curvature, to allow more lift. Loons have the smallest wing surface in proportion to their weight (wing load) than any other flying bird.

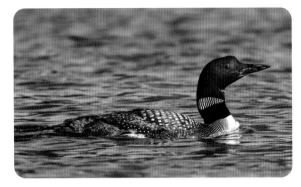

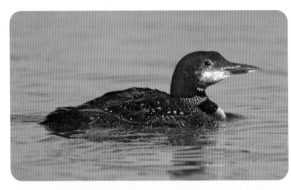

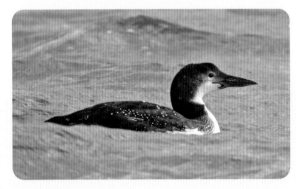

CHANGING PLUMAGE

The sleek black-and-white breeding plumage of the loon is known as alternate plumage. The loon's winter or basic plumage is a combination of gray and white.

The fall molt begins around the bill and face. The new gray and white feathers on the face sometimes gives the bird the appearance of having a white mustache. Molting continues down the head and neck to the main body. Flight feathers (primaries) are molted during winter in January and February. Since many primaries are molted at the same time, loons are rendered flightless for up to 2 months while their new feathers grow.

Most birds molt all their feathers twice a year (biannual molting), once in late summer/early fall and again in late winter/early spring. Adult loons (except for Red-throated Loons) also molt feathers twice a year, but molt their flight feathers only once a year in late winter/early spring.

The underside (belly) of adult and juvenile loons is white. White belly feathers make loons on the surface of the water difficult for fish to see. The white color also helps to hide young loons from underwater predators such as Muskie and Northern Pike. During winter, when adult and juvenile birds are on coastal waters, the color helps to hide them from salt-water predators such as sharks.

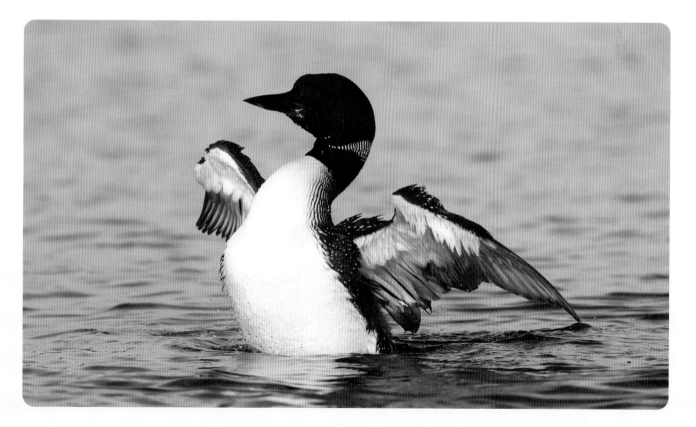

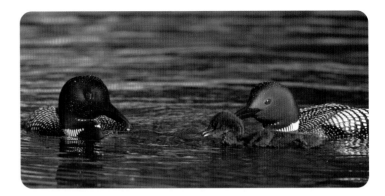

Loons have a unique coloring. At first glance or on cloudy days, breeding loons appear black and white. On sunny days or when the sun is low in the horizon, they appear iridescent green or blue and white. Their black feathers are iridescent due to cell structure and shine green or dark blue, depending upon the amount and angle of the sun.

The coloration of the black and white feathers is due to the presence or absence of a pigment known as melanin. The more melanin, the darker the feather. Feathers without melanin are white.

More melanin increases feather strength, thus dark feathers are more resistant to abrasion due to everyday activity such as flying and coming in contact with branches or, in the case of loons, aquatic vegetation. In addition, melanin causes feathers to be stiffer than those without melanin.

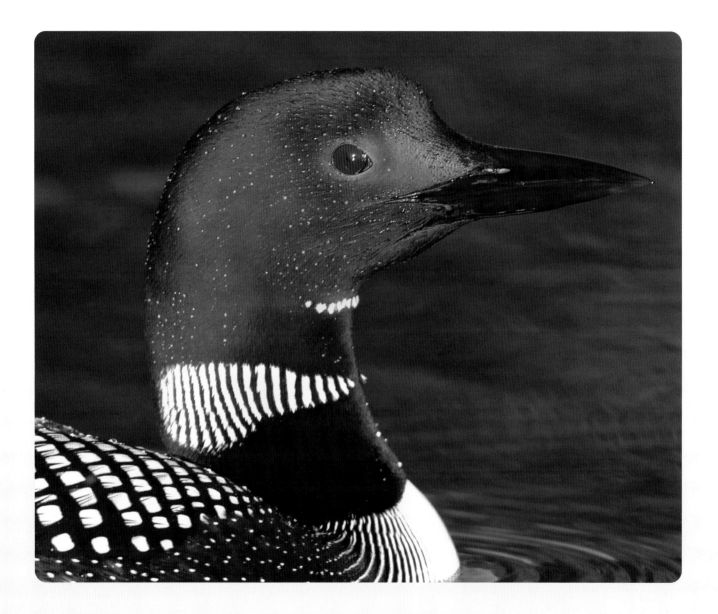

Some people have speculated that the black-and-white breeding colors allow loons to blend in with the surface of water and be inconspicuous to predators above such as Bald Eagles. This doesn't seem sensible because the water is often blue, so another reason seems likely.

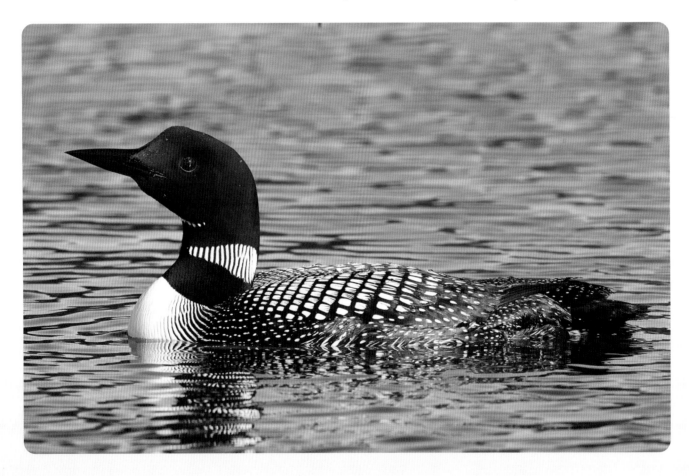

Others believe that the bold black-and-white pattern allows the bird to be seen and visually communicate a warning. Warning colors such as these are known as aposematic coloration. For example, a loon flying over a lake would easily see the bold black-and-white coloring of another loon in a territory below, indicating the lake is occupied. The flying loon won't waste energy by landing and taking off after seeing the loon on the lake. Not landing would also reduce conflicts among loons–another huge energy saver.

For reasons we don't understand, the contrasting colors have stood the test of time. Interestingly, other birds such as penguins, murre and auklets also have black and white patterns, so it's obviously a good combination that works well for birds that spend much of their time in open water.

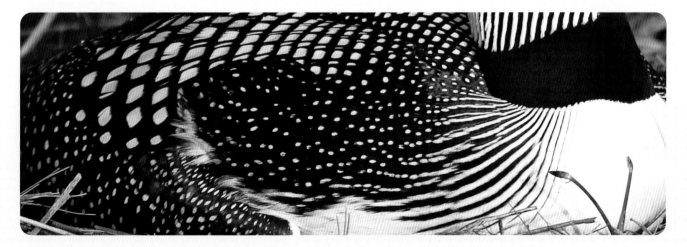

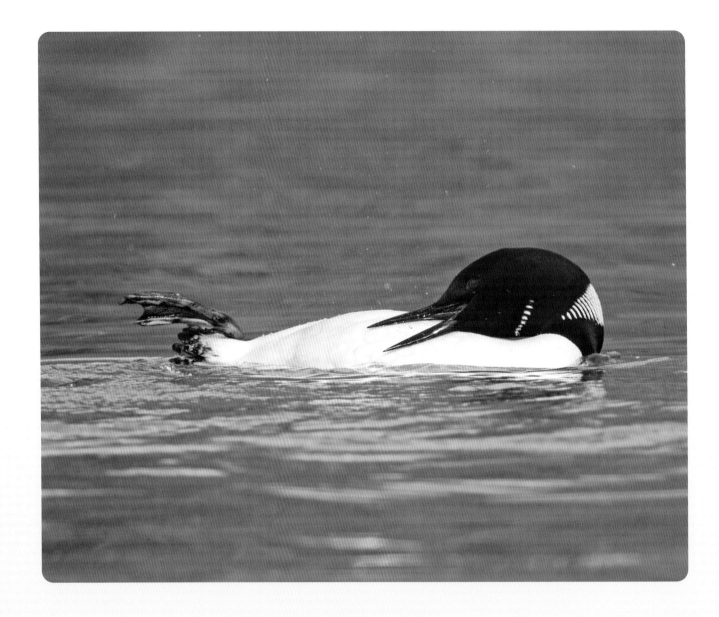

PREENING AND WATERPROOFING

Much of a loon's day is spent cleaning and adjusting feathers. This feather maintenance behavior is known as preening. In all birds, care of feathers is paramount to survival.

The typical feathers that cover a bird's body and wings are contour feathers, curved or cupped feathers that match the contour of the body or wing. A contour feather has a stiff central shaft with a series of barbs on each side. Barbs are held together by tiny barbules, which form a flat surface or web. Barbules look like tiny hooks and work like the teeth of a zipper.

During daily activities such as flying or swimming underwater, barbules often become unhooked or unzipped. To provide a smooth and thus waterproof coat, the feathers need to be zipped together, which is what preening accomplishes.

Loons preen with dry bills or immediately after dipping their bills in water. Loons also preen with oil, squeezing oil from the uropygial gland at the base of their tails. Spreading oil over the feathers with the bill creates a waterproof coating and allows a loon to shed water the moment it resurfaces.

All feathers need an oily coating to stay waterproof, but even the most flexible loon can't reach every part of its body with its bill. To coat the head and neck feathers, a loon spreads oil on the large contour feathers on its upper back and shoulders, throws its head back and rubs against the oil deposits. Repeating this action ensures an even spread of oil over the head and neck.

NIBBLING

Loons spend a lot of time preening the small white feathers on the chest and abdomen. While floating, a loon will roll to its side and sometimes onto its back, exposing its belly above the surface of the water. Grasping and pulling these small feathers individually through the bill is called nibbling. A loon will often reach deep within the thick layer of chest and belly feathers to pull out an individual damaged feather. This is often done while splashing to wash away debris that is also pulled from the feathers, and can go on for many minutes.

BATHING

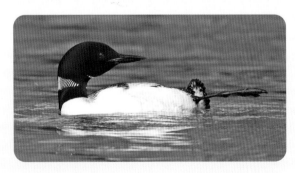

Bathing involves more vigorous splashing and submerging. Between splashes, a loon may pause momentarily to preen and nibble. Loons also completely roll over while thrashing water with partially opened wings, causing the greatest splashing. A loon will intersperse splashing with dipping its bill and sometimes its head into the water to wash its face.

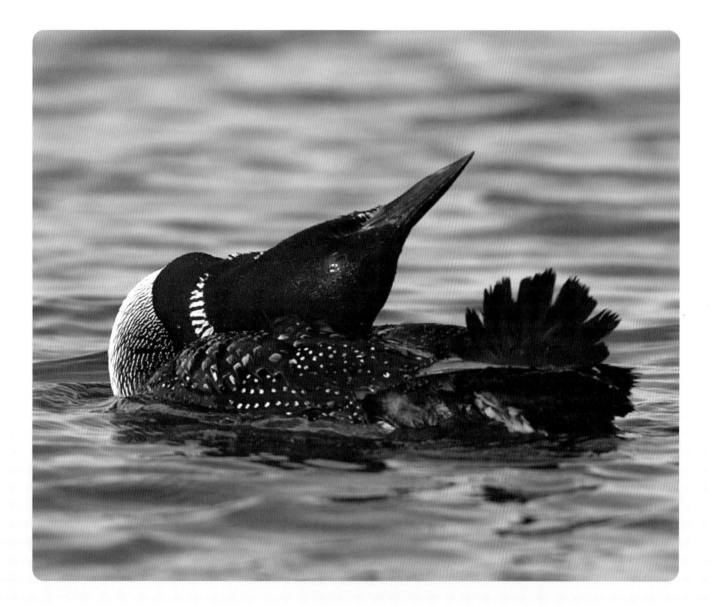

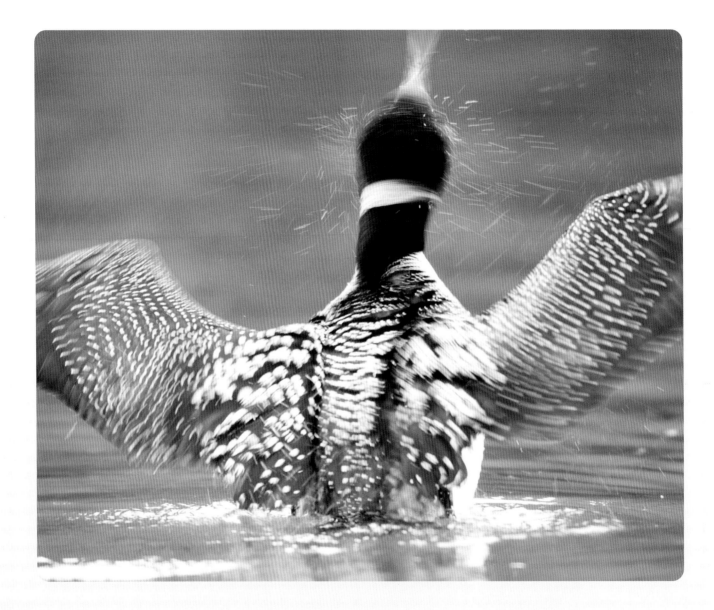

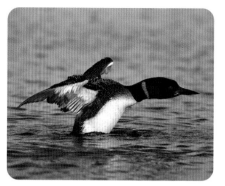

BODY SHAKING AND WING STRETCHING

After preening and especially bathing, loons usually shake or wing stretch. Body shaking–rising up out of water and vigorously shaking–removes trapped water droplets and realigns ruffled feathers. Wing stretching usually occurs at the end of a preening session. During a wing stretch, a loon rises high up on the surface of water. With neck outstretched, bill held high and wings spread, the loon flaps several times while shaking its head and neck.

A loon shows sociability when wing stretching by pointing its bill upward. When a loon stretches its wings and points its bill downward or tucks it tightly against its neck, it is taking an aggressive stance.

TAIL WAGGING

Tail wagging usually follows wing stretches. The loon holds its tail above the water's surface and shakes it from side to side, expelling water and air drying the stubby feathers.

After grooming, loons sometimes swim for a short time with their tails erect.

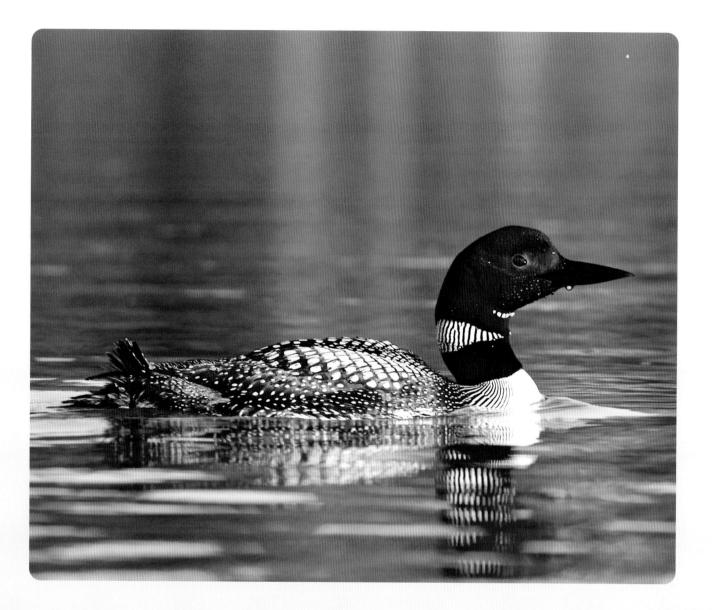

SEASONAL DIET OF WHOLE FISH

Loons are primarily fish eaters, but they also like crayfish and aquatic insects. They find food only by eyesight and prefer clear deep lakes. Small fish are eaten underwater. Larger fish are brought to the surface and swallowed headfirst and whole. At the surface, a fish is often manipulated back and forth in the bill many times, with pressure from the jaws presumably paralyzing or killing the fish before it is swallowed.

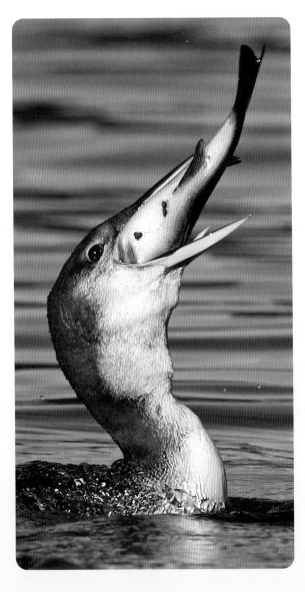

A loon's digestive system is different from Ospreys, Bald Eagles and other large birds that also eat a lot of fish. Ospreys and eagles regurgitate pellets of undigested food such as bones and scales. Loons have a large gizzard that is powerful enough to grind even the hardest foods such as bone and crayfish shells. The gizzard is lined with keratin (similar to fingernails) and contains small stones that the bird has ingested from the bottom of lakes. The stones act like grit and do the grinding.

Loons feed on freshwater fish in summer and saltwater fish in winter. The extra salt ingested during winter months is excreted as a concentrated salty solution through large glands near the eyes. The ability to switch diets is a unique adaptation in loons that is not well understood.

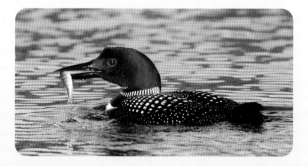

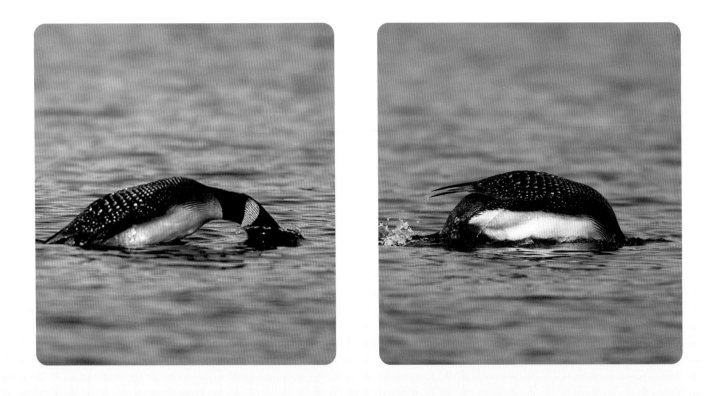

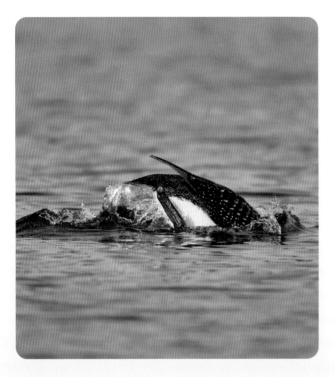 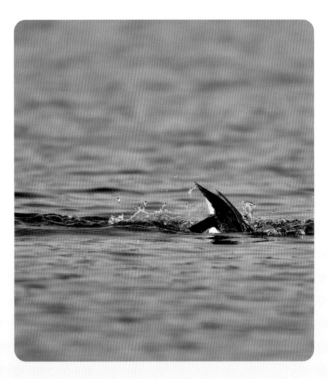

Loons compress their body feathers just before diving to squeeze out trapped air. Squeezing the stiff feathers together before diving also helps loons expel oxygen from specialized air sacs within their bodies. Then, arching their backs and rising slightly out of the water, they dive, slicing headfirst into the water, making very little splash.

When adult loons are hunting for fish, their dives last 30-90 seconds. Diving time is shorter on shallow lakes or on lakes with abundant food supplies and longer on deeper lakes or on lakes with fewer fish. While loons spend an average 30-90 seconds underwater, they are able to remain underwater for up to 3 minutes.

Loons are thought to dive as far down as 150 feet (46 m). However, most dives are much shallower and average around 30 feet (9 m). Loons dive in only a few feet of shallow water when feeding on crayfish or minnows.

When diving, the heart and central nervous system go into a diving reflex that lowers the heart rate by about half, which reduces the rate oxygen is moved around the body, thus reducing oxygen consumption. When the diving reflex kicks in, the body muscles switch to an anaerobic metabolism (without oxygen). This helps to conserve oxygen and reduces carbon dioxide output. The breathing center in the loon's brain has a high tolerance for carbon dioxide, which allows the bird to spend more time underwater without having the urge to breathe.

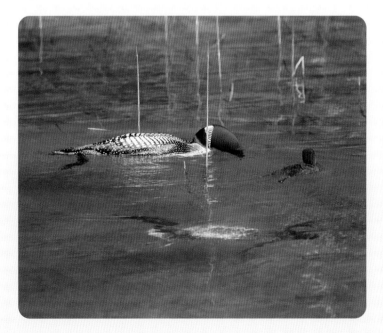

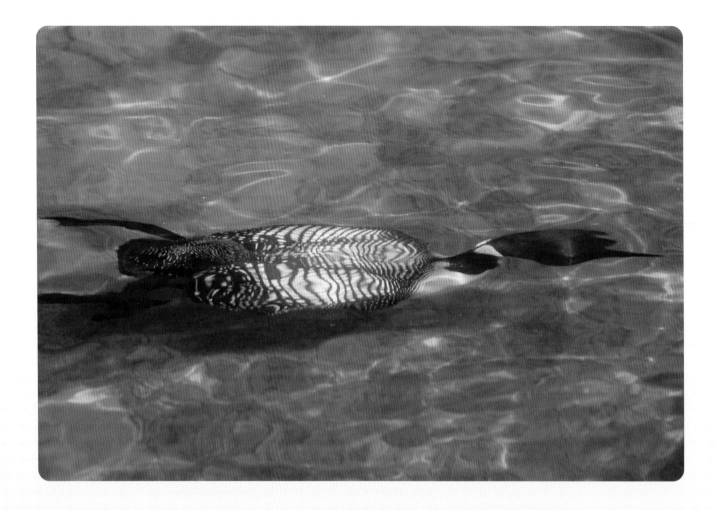

SWIMMING UNDERWATER

Loons don't use their wings to swim ("fly") underwater–the wings remain at their sides. The shape of the body allows loons to slip quickly through water, with their waterproof feathers further reducing resistance.

SUBMERGING LIKE A SUBMARINE

Loons are able to submerge gradually without diving head-first like ducks. They can control their specific gravity by compressing their feathers and expelling air from their specialized air sacs and their lungs until their body weight is the same as the water. Because air is expelled, the oxygen they need does not come from air in the lungs but rather from oxyhemoglobin and oxymyoglobin stored in the blood and muscles. These are the substances responsible for the dark meat tissue in most birds.

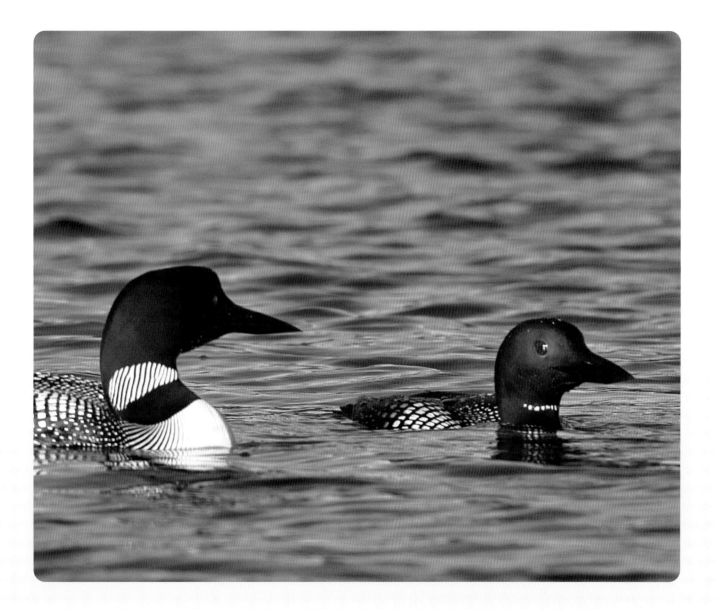

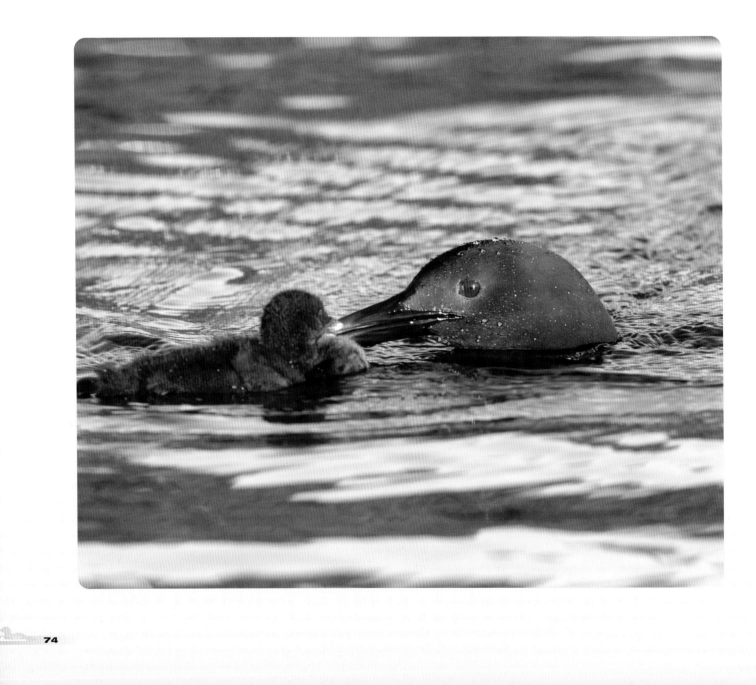

Unlike ducks, which pop up to the surface like corks, loons can surface slowly or with just their heads showing above water. When loon parents need to hold fish to feed their tiny chicks, they surface at the height of the chicks and pass the food at the chicks' level.

Loons also surface stealthily, with just the top of their heads and nostrils showing, to take a breath and head back underwater again. Silent partial surfacing can lead even keen-eyed observers to believe the birds are staying underwater much longer than is apparent.

Incubating parents will quietly slip off their nest, go directly underwater, surface farther away and return in the same way. Using this discreet action, the attention of predators such as raccoons or skunks isn't attracted to the location of the nest.

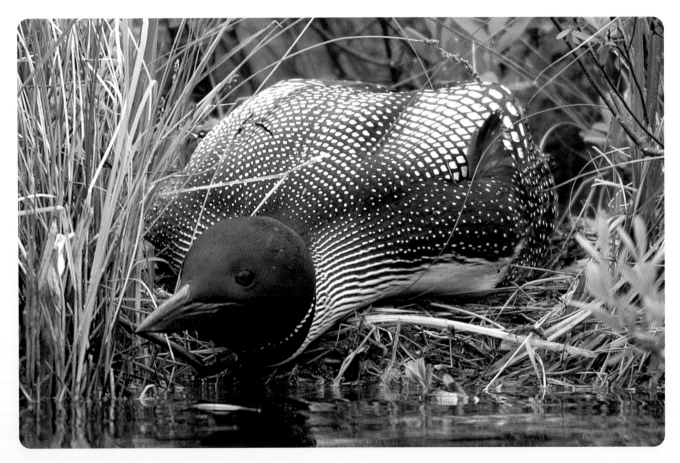

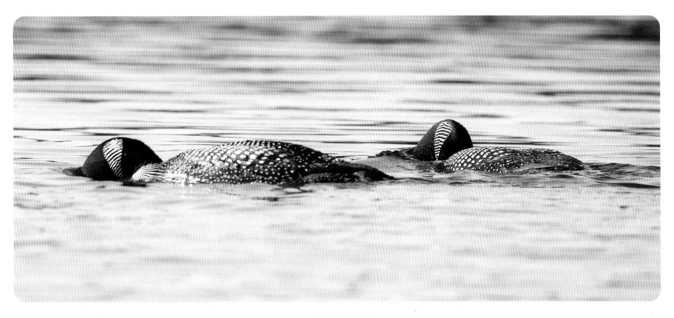

PEERING

While floating on water, loons often dip their heads under-
water to look below the surface. This behavior is called
peering. Adult loons and juveniles peer to locate fish and
keep track of other loons. Juveniles often peer to observe
their parents chase and catch fish.

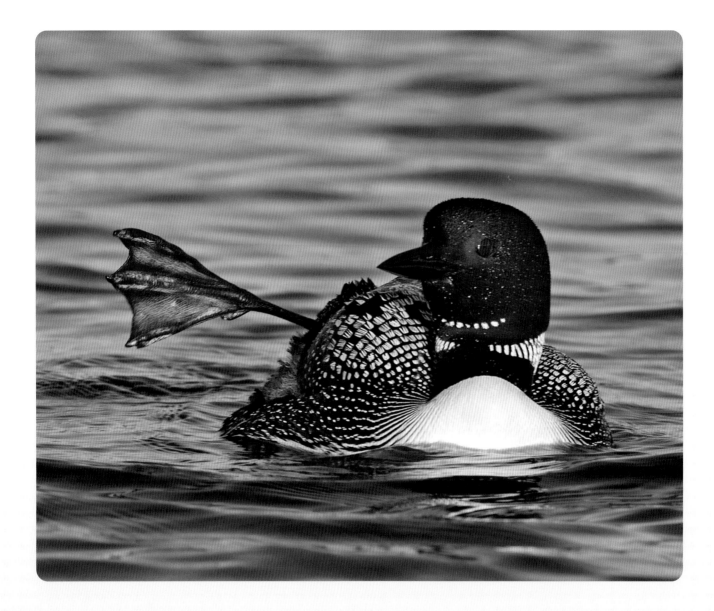

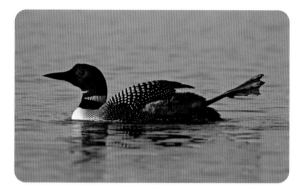

FOOT WAGGLING

Loons are often seen stretching one foot and waving it about. This behavior is called foot waggling or foot waving. It is thought that the large feet help regulate body temperature. When a loon is cold, it lifts a foot out of the water, shakes off water droplets (foot waggling) and tucks the foot under a wing to keep warm. In much the same way as we put our hands in pockets to keep warm, loons put an exposed foot under a wing for warmth. The evaporative effect of water could also cool a hot bird, but since they spend nearly all their time in relatively cool water, foot waggling seems to support the idea of warming rather than cooling.

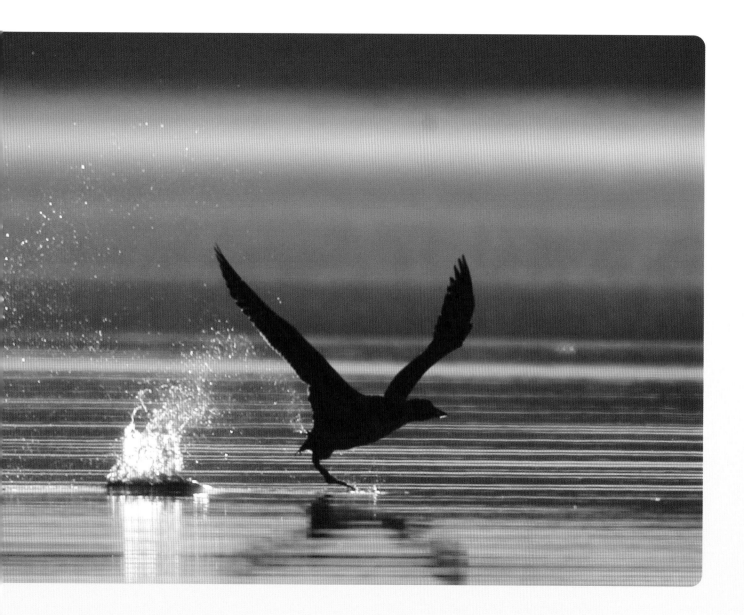

TAKING OFF INTO THE WIND

To take off, loons need to run across the surface of water. Facing into the wind, they back up to get a long stretch of open water. The distance required to take off depends upon the wind, but up to 500 feet (150 m) is needed in a calm wind. Shorter distances are necessary when loons are flying into a headwind.

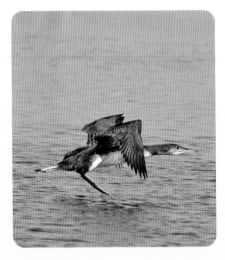

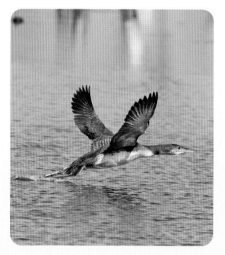
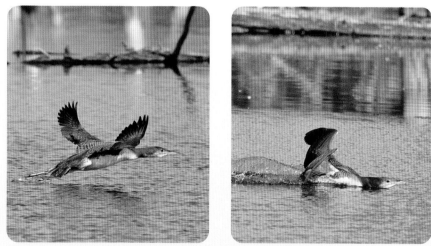

Young loons practice taking off and landing around August. The young loon in this photo series practiced takeoffs and landings five times in one hour. After each test flight, it swam back to the opposite side of the lake to face into the wind and try again.

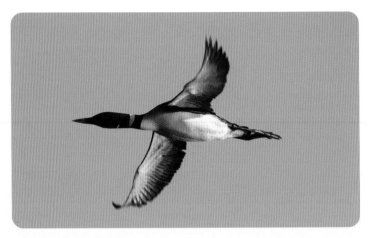

RAPID, SHALLOW WING BEATS

In flight, loons look like a large plus sign, with wings often positioned above the body. Many other birds use full flaps that extend well below the plane of the body. Due to over-sized wings, loons only need to make shallow flaps. Loons make 260–270 rapid, shallow wing beats per minute, or 4 beats per second. They need to flap rapidly due to their high weight-to-wing surface ratio. It takes more energy for a loon to fly because of its heavy weight. Rapid wing beats use more energy and also produce excess heat.

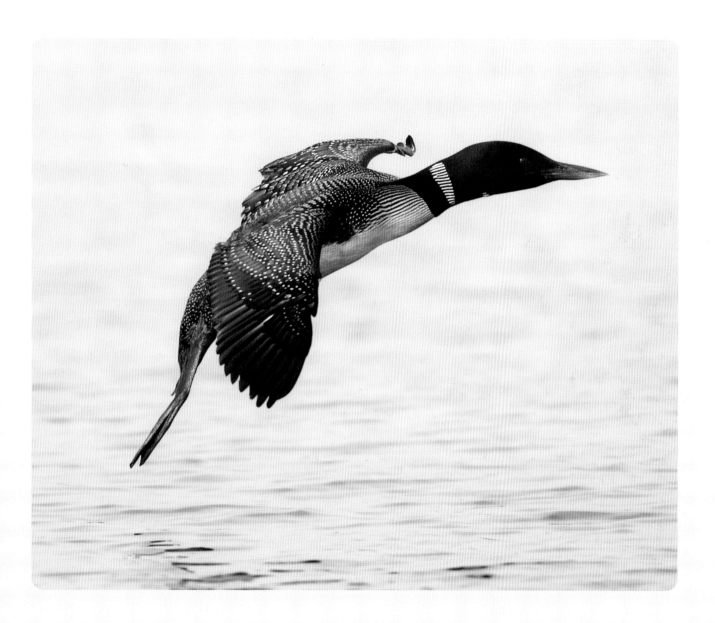

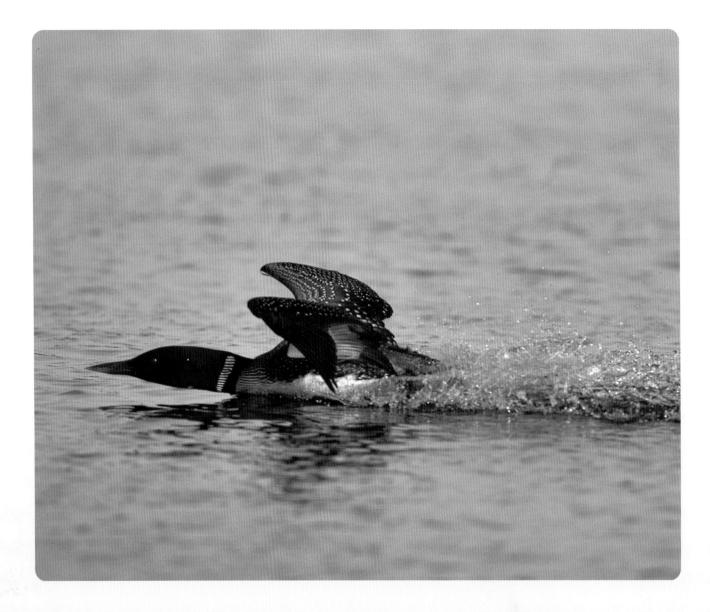

DESIGNED TO LAND ON WATER

When landing on a lake, loons hold their wings very high over their backs to avoid clipping a wing on a wave or the surface of the water, resulting in a crash landing.

Some loons land on large, empty parking lots, mistaking them for the flat open surface of a lake. When a loon is on land, it is unable to take off. The oversized feet are so far back on the body, they are excellent for propelling during swimming, diving and chasing fish, but make a loon awkward when on land. Loons can't walk the same way as ducks, swans or other birds of similar shape. Instead, a loon will push itself along, dragging its breast on the ground while its feet prop up the rear. Even though a loon has to push most of its body along the ground, it can move quickly on land and may use its wings to help push when needed. A land-bound loon needs to be captured and transported to a lake large enough to facilitate takeoff.

Adult loons spend about the same amount of time on the surface and underwater. At night, loons stay on the surface but don't hunt, since they can't see in dark water. Loons also sleep or take naps during the day. Like other birds, loons tuck their bills under a wing and close one or both eyes. Many studies show that ducks and geese have the ability to sleep with one eye closed, effectively resting one-half of their brain. Whether loons are able to do this is unknown, but it is likely they can.

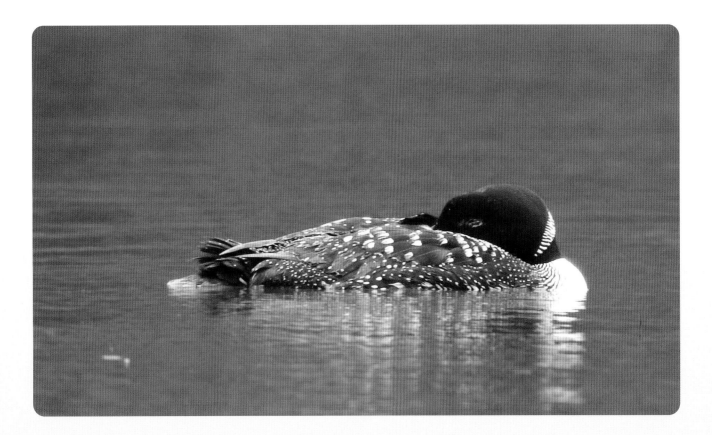

THE VOICE OF THE WILDERNESS

If you've ever camped at the edge of a northern lake and listened to the cries of loons, you know the enchantment of their calls. Loons are the voice of the wilderness. The power of their midnight chorus typifies the lakes and forests of the great Northwoods.

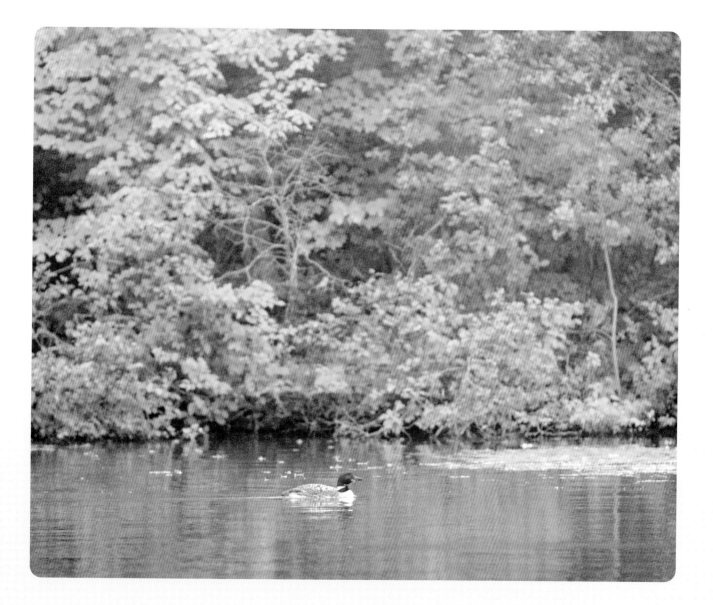

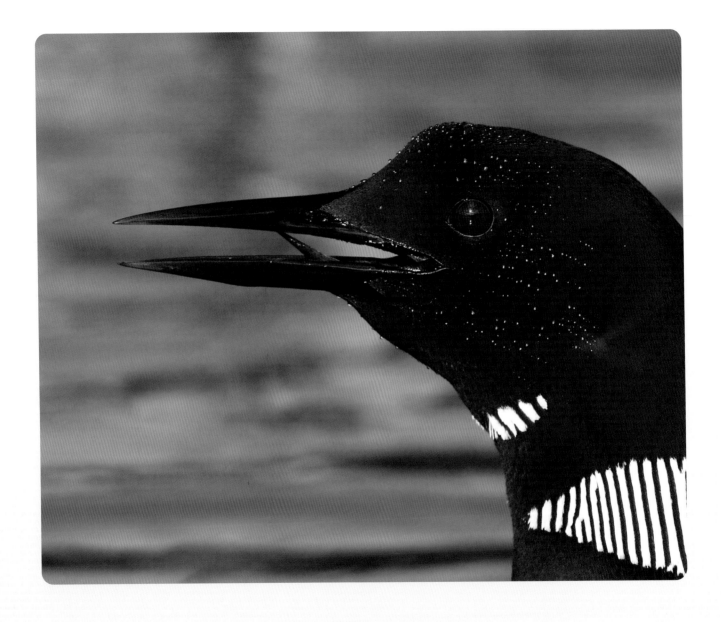

COMMUNICATING WITH CALLS

While loons delight us with their ethereal sounds, they call simply to communicate with other loons. Compared with the calls of songbirds, loon calls are basic and functional. Biologists have found that loons have four basic calls—the wail, the tremolo, the yodel and the hoot. Each call is modified to produce variations, but the basic calls are still the mainstay of their communication. While single individuals usually stick to the standard calls, groups of loons often become very creative in their calling, combining calls or linking them together to make new calls.

Songbirds have much smaller territories than loons and relatively quieter calls that can be heard throughout their area. Loons have large territories that span up to hundreds of acres. Because of that, they produce much louder calls to communicate with other loons up to several miles away.

Air conditions such as calm winds, clear skies and low humidity allow sound to be carried farther than at other times. Loons often call just before and after sunset, when favorable conditions for long-distance calling often occur. Although loons will call anytime, most calling takes place at night and peaks near midnight.

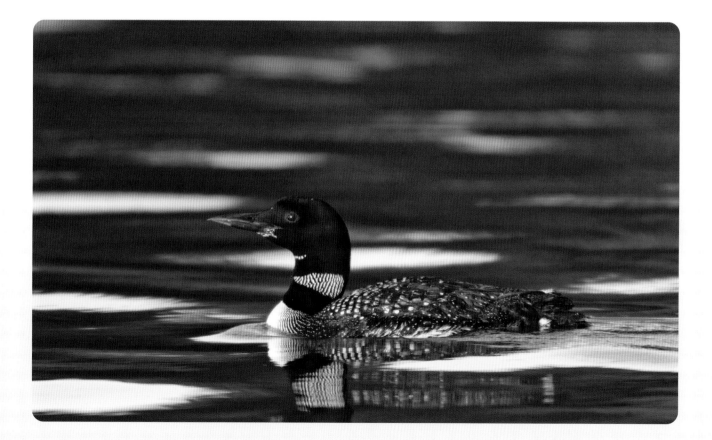

THE WAIL

The wail is an all-purpose call that expresses a loon's desire to be closer to other loons. It means, "Where are you?" or "Come here!" Wails are also given when a loon feels anxious or threatened.

The wail rises and falls in pitch and often sounds like the howling of a wolf. Wails have three forms. The one-note wail is a single unbroken note that does not change. The two-note wail begins on one note and moves quickly to a second note of higher frequency. The three-note wail adds a third, higher note to the two-note wail.

Wails are used to call to mates and family members. Males wail to females to come ashore and mate. Others wail to mates upon their return from neighboring lakes. Adults wail to chicks to leave an area or to come out of hiding, while still others wail for relief of incubating or brooding duties.

After hearing a wail, loons often swim toward each other. The more intense the wail, the more urgent the need to come together.

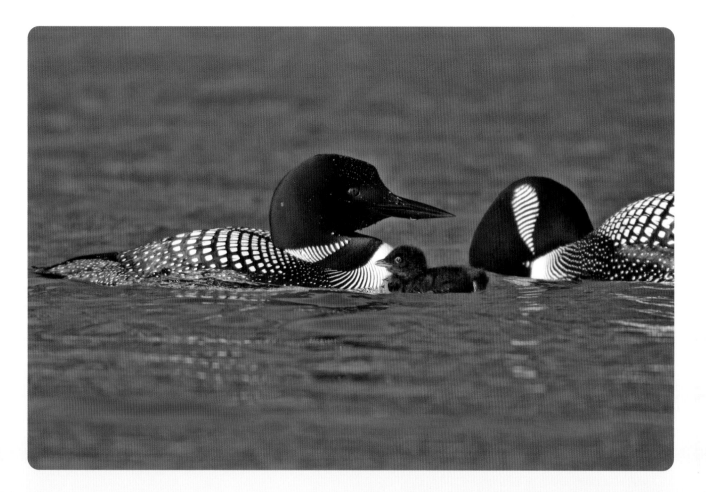

Families use a special wail to communicate—usually a soft, one-note wail known as a "mew" or "ma" call. This is a soft call that rises to a higher frequency in the middle, then falls to a lower pitch that lasts only one second.

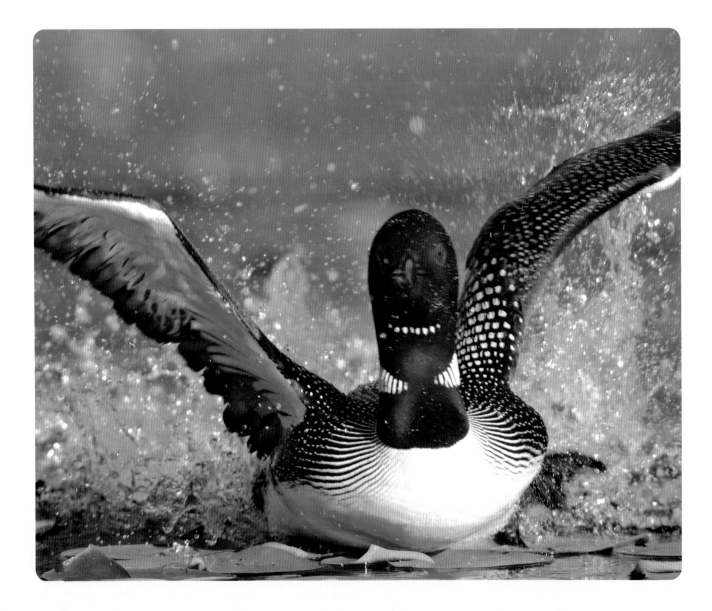

The tremolo of a loon is known as the laughing call. The laughing tremolos of males are lower than those of females. Tremolos are mostly given during the day.

There is physical evidence that the laughing call is comprised of two overlapping notes. It occurs when the two parts of a loon's syrinx (voice box) make two sounds simultaneously, with one note from the left side and one note from the right. This is known as a two-voice phenomenon and is common in many bird species.

An alarm tremolo is given when a loon is feeling threatened or is threatening another bird. The alarm call is the most common call people hear because loons give it when they are approached by people. This type of tremolo changes and intensity increases as a threat approaches. Alarm calls are often given with splashing displays.

Tremolo calls delivered in flight are known as flight calls. Flight calls tend to have a short, consistent length and can be timed to match the flapping of a loon in flight. Flapping compresses the chest wall and highly affects the respiratory rate. The flight tremolo may be the only call a loon can make during flight due to the respiratory effort. Flight calls are usually given directly above a loon's territory and are not usually issued by those about to land.

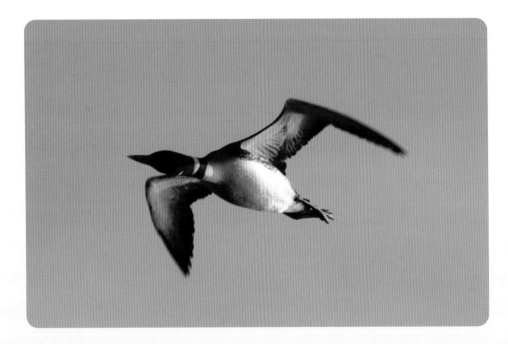

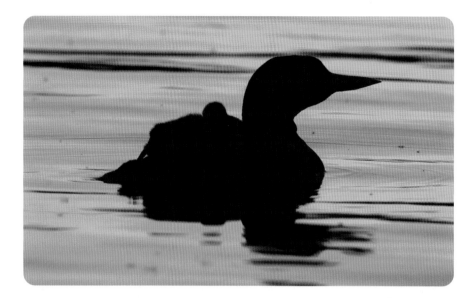

Tremolos are often given in duets, with one pair member calling at a slightly different frequency. This has the effect of exaggerating or maximizing the call. While duet singing in songbirds such as Northern Cardinals is used in pair bonding, duet tremolos are not thought to be used this way in loons.

Duet tremolos are often given when both mates leave their territory at the same time. When a pair takes flight, they circle over their territory once or twice and deliver the call. This presumably lets loons in the vicinity know the territory is taken even though the owners are absent.

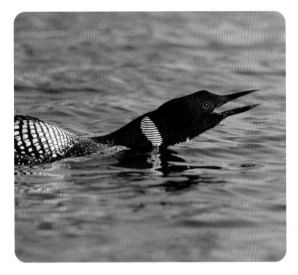

THE YODEL

The yodel is a danger or warning call given only by male loons to announce and defend territory. Males yodel when people come too close to an individual, the young or a nest site. The yodel is unique to each bird, allowing for individual identity by sound. It means, "I am a male loon, I'm on my territory and I'm prepared to defend it!"

Yodels are used in aggressive displays and encounters and are given most often when loons are nesting and raising young. They are issued before and during hatching–the time when adults expand their territories, presumably to increase access to food for their growing families.

The pitch of the yodel is different across the geographic range. Studies comparing frequency and amplitude found that loons in Minnesota have the highest voices, loons in New York have the lowest and Saskatchewan loons fall somewhere in the middle. There is some evidence that the larger the bird, the lower the voice and vice versa. Loons in Iceland and Canada's Baffin Island are the largest and have the lowest voices. Loons in Minnesota are smaller, with higher voices.

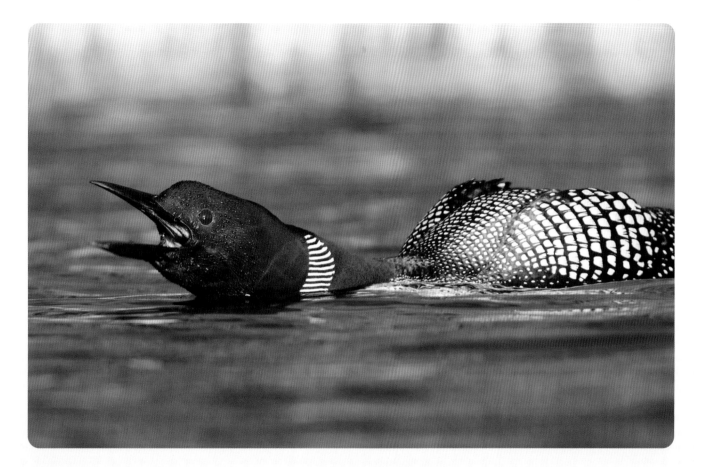

Males often assume a unique posture when yodeling. With head and neck stretched forward horizontally and bill just above the water's surface, a male will move his head back and forth as if spraying the call all over the lake.

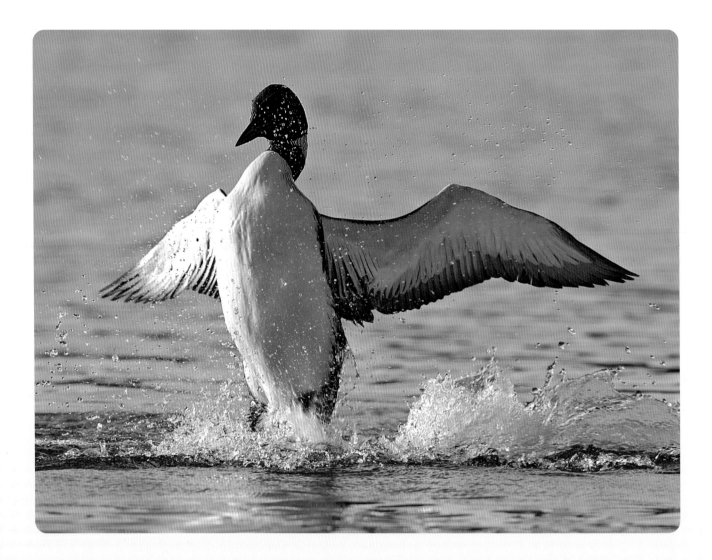

Males may strike another posture during yodels known as the vulture position. A male will rear up high in the water and crook his neck while delivering the call. The position is often taken when a loon is in close confrontation with another, and is thought to be a simultaneous audio-visual display.

The hoot is a short, single call note, usually given by family members nearby. Considered a contact call, the hoot permits individuals to keep in auditory contact while they look for fish, scan for danger or watch for other loons.

Hoots are also given when an adult approaches a group of other adult loons for a social gathering.

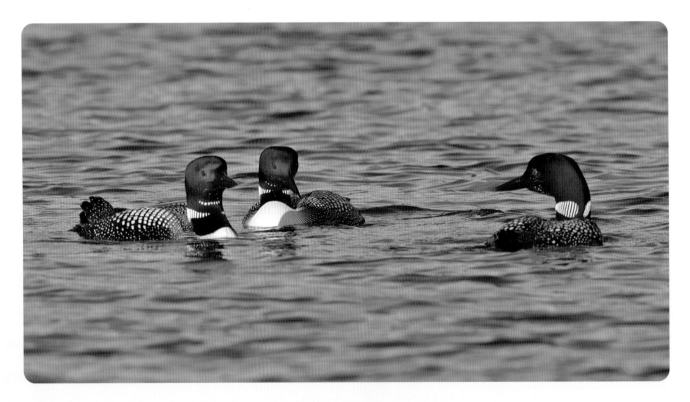

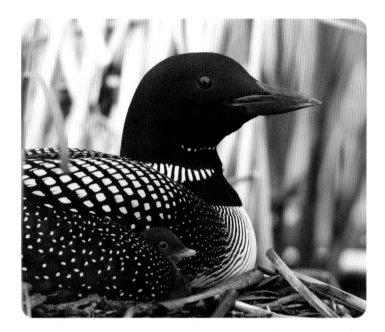

CHICK CALLS

Baby loons start to peep even before they are hatched.

After hatching, baby loons communicate in the same way that other baby birds keep in touch with their parents—with soft peeping calls. Loon babies peep for several days to beg for food.

Baby loons can produce a loud yelping call the first day after hatching. This is a single note call, higher in intensity than the peeping call.

Loon chicks start wailing at 1 week of age (as shown). The wail call is used for more intense begging. Wails are also given to signal distress.

Loon chicks 3-4 months of age deliver wails and tremolos that are indistinguishable from adult loon calls. They also stop peeping and yelping and start hooting. At this age they use a consistent wheezing call to beg, even though they are perfectly capable of catching their own food.

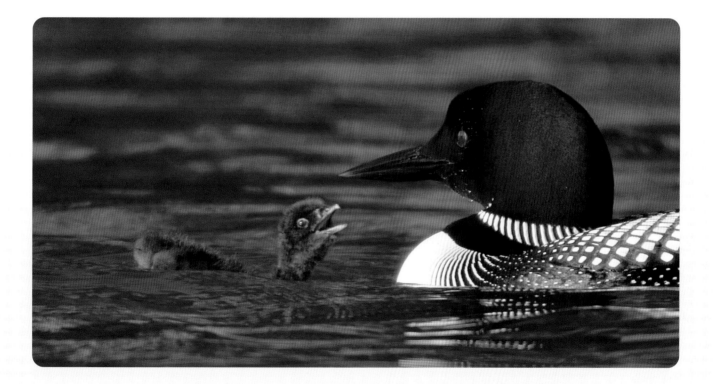

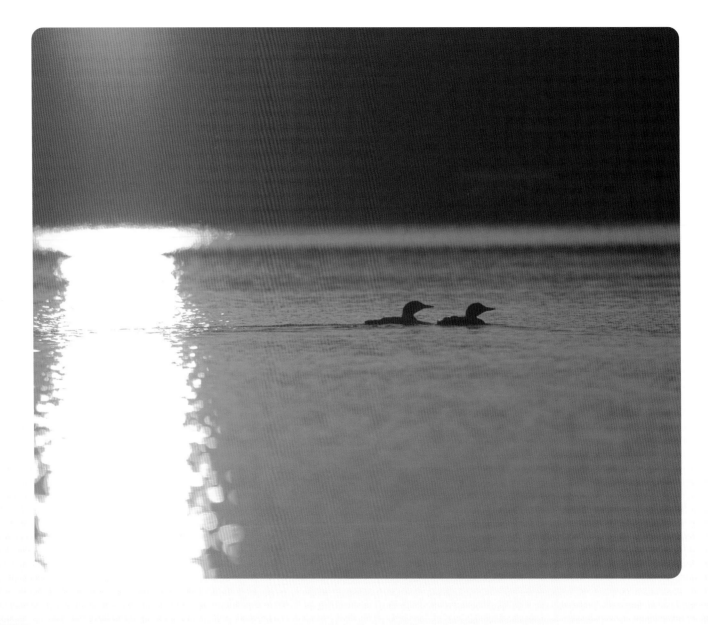

Courtship between mated pairs is a simple affair. They spend the entire day together, fishing, feeding, diving, preening and sleeping. Pairs actively keep other loons out of their territory and mates work together to build a nest. Oddly enough, copulation takes place on land, with nest construction usually coinciding with the reproductive activity.

Older, more experienced loons tend to keep the same mate for many years and may mate for life if they stay successful with their partner at reproducing young. Younger, less experienced loons who have suffered nest failure often "divorce." The following year, they'll seek a new mate and nest location. This process goes on until they become successful at producing a family.

Mated pairs with young stay together all summer until migration in autumn. Mated pairs that have had nest failure or that have lost their young will separate by midsummer and start molting in late summer. Adults with young molt later, perhaps after arriving on wintering waters. There is no evidence that mated pairs migrate or spend the winter together.

In mid to late summer, adult loons congregate in groups of 3-30 on large lakes. These groups are akin to social gatherings. Social gatherings occur over deep water, usually between territories or at neutral sites. Loons will often gather in early morning and late afternoon, although large social gatherings also occur in midmorning and at midday.

Evidence supports the thought that social gatherings function to reinforce cooperation among adults. When non-resident loons fly into the social arena, resident or host birds quickly swim out to join the visitors.

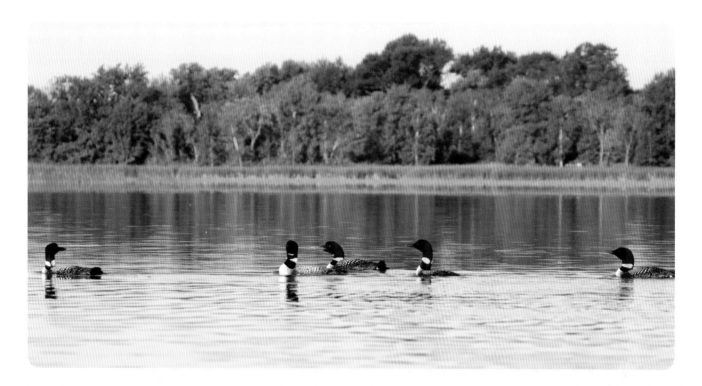

While both members of pairs attend gatherings, often only one parent attends when the young are too small to leave alone. When a social gathering is held on a small lake that is occupied by a pair with chicks, the resident pair will hide their young in thick vegetation and host the meeting away from the hiding place.

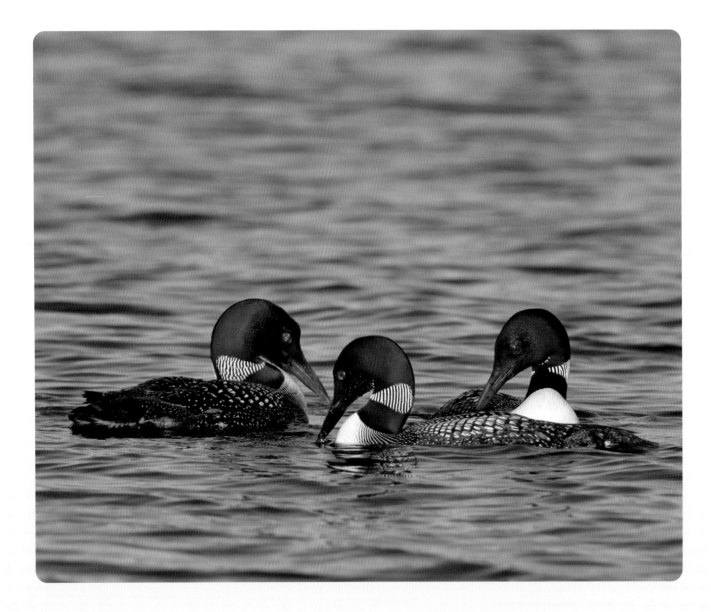

Social meetings usually start with many hoot calls among the group, followed by tremolo calls and much splashing and running on the water. Yodel calls are usually given after all loons have left the meeting.

Social group participants meet face to face in small groups of 3–30 and swim in a tight circular pattern with their heads cocked to one side. One member dives suddenly while the others peer from the water's surface, then follow the lead with an exaggerated splashing dive. Circular swimming and mutual diving continues for several cycles. Individuals break off and couples go their way before returning to their lake territory, while resident birds swim back to their young.

Social gatherings become larger and last longer later in the summer as adults are freed from the obligations of caring for their young. In late summer when juvenile loons can fly, the young gather together for a social time of their own. Juvenile birds stay together all day and sometimes for several days before migrating for the season.

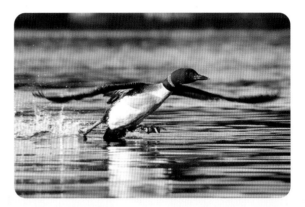

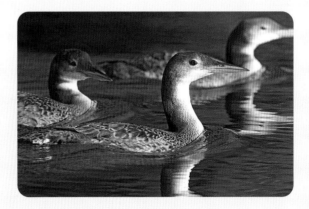

Loons build their own nests. Construction is a joint effort, with both parents doing equal work. Nests are built on nesting sites that were successful the previous year.

Loon nests are typically made with vegetation such as moss, twigs, sedge and leaf litter pulled from the immediate area. Some nesting material is retrieved from the lake bottom, often for the base of the nest.

Some nests are 2-3 feet (.6-.9 m) wide and weigh 20-40 lb. (9-18 kg). Nests are sometimes built on top of muskrat lodges, making those nests appear even larger. Most nests are small affairs, consisting of only a few inches of plant material. Occasionally, when enough vegetation is not available, loons lay eggs directly on gravel or sand.

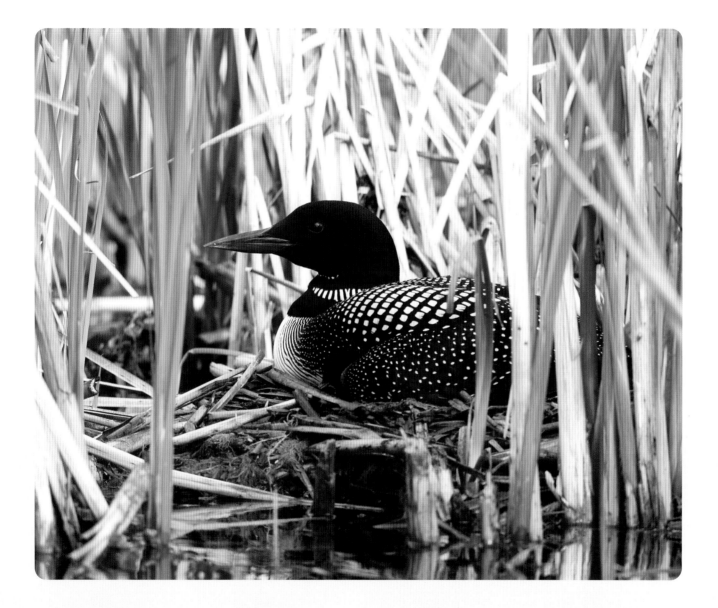

Nests are usually built on the ground adjacent to water. Nests are often placed near deep water since water levels in shallow water fluctuate more during droughts and heavy downpours. Because deep water levels are more stable, nests are less vulnerable to changing water conditions such as flooding.

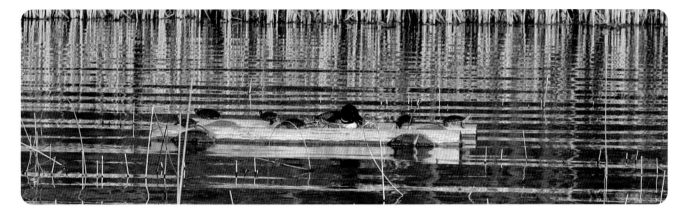

ISLAND NESTING

Loons prefer to build their nests on small islands or floating mats of vegetation. Field observations show that 80-90 percent of all nests are located on some sort of island. Given the choice between an artificially constructed island such as a floating platform of vegetation and a location on land, loons select floating platforms or other artificial islands about 80-90 percent of the time. Muskrat lodges are sometimes used when the vegetation can be rearranged to make a depression on top for laying eggs.

Loons nest on islands to reduce the chances of predators finding their eggs. Studies show that raccoons are the primary predators of loon eggs, followed by skunks. While raccoons and skunks can and will swim, nesting on an island greatly reduces this threat.

WATER ACTIVITY AND NESTING

Adult loons have different pre- and post-nesting behaviors during summer that are sometimes referred to as time activity budgets. Before nesting, studies show that loons spend more time underwater than on the surface. During nesting season, they spend more time on the surface because they are incubating eggs 24/7. After nesting, they spend equal time on and underwater since they are busy foraging for and feeding their chicks.

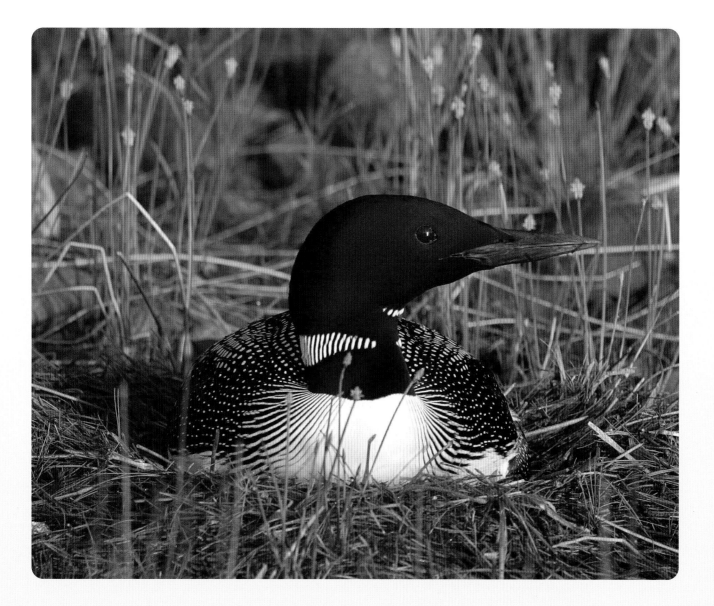

If the first clutch is lost or the nest fails, loons frequently move the nesting location and renest the following year. Successful sites are usually reused for many successive years. While the majority of loons occupy the same nest territory for many years in a row, there is some turnover–almost as high as 20 percent each year. This may be due to mates dying or individuals that are stronger and more aggressive driving out the resident birds.

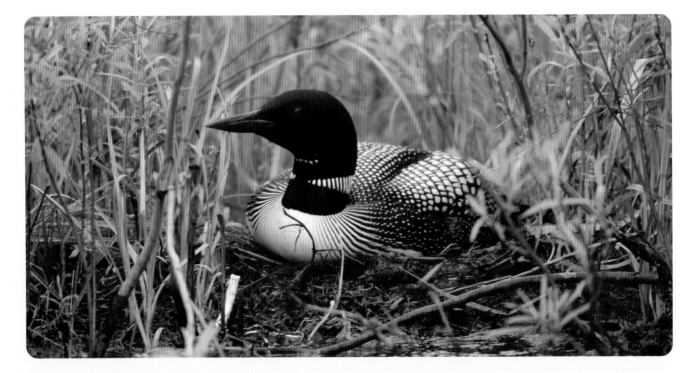

EGGS AND INCUBATION

Loons lay two large thick-shelled eggs each spring, 1-2 days apart. Adults start incubating immediately, which means the eggs should hatch 1-2 days apart (asynchronously). Most studies, however, show that most clutches of two eggs hatch within 24 hours of each other, indicating that one egg took less time to incubate than the other. Incubation takes 27-30 days, with both adults incubating the eggs about an equal amount of time. In some pairs, the male incubates more than the female. However, in the majority of loon families, the female incubates slightly more than the male.

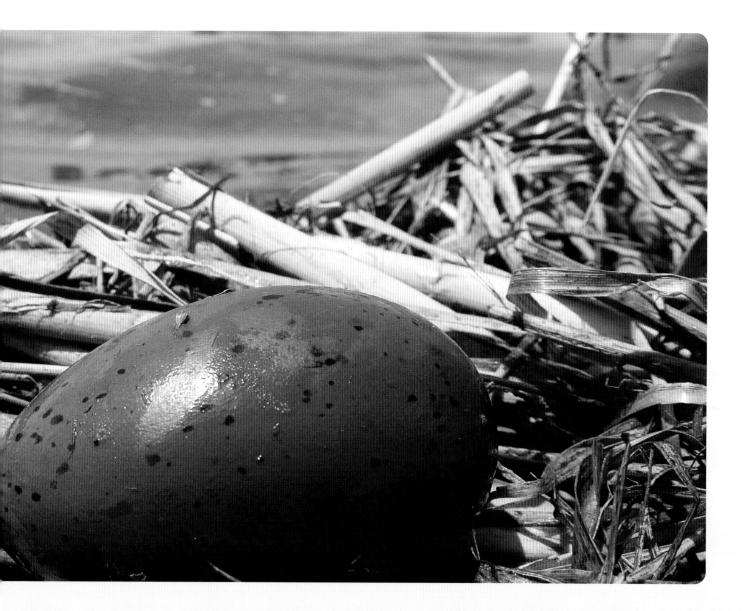

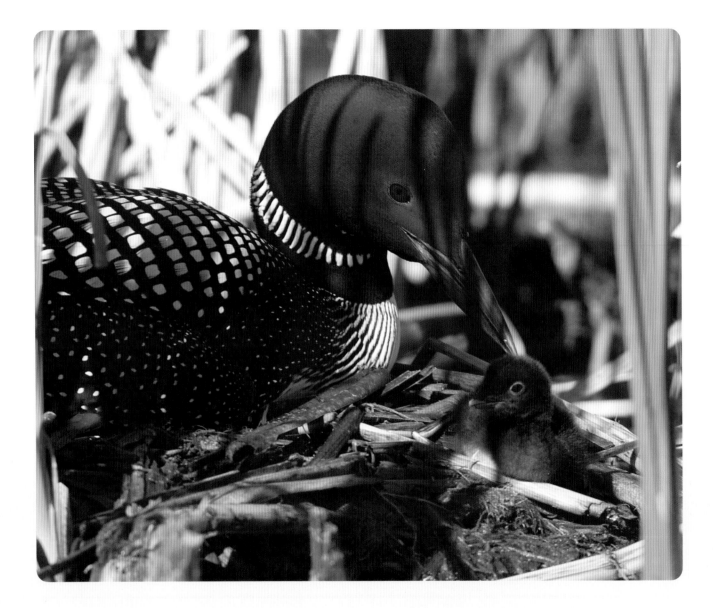

OUT OF THE NEST, INTO THE WATER

Most chicks leave the nest within 12-24 hours of hatching and enter the water. Chicks that hatch in the afternoon stay in the nest overnight.

It is thought that once chicks leave the nest, they may not touch land again until they are 5-6 years old, when they start to nest. Studies show some will breed as early as 4 years of age; however, one individual was 11 years old before it nested for the first time.

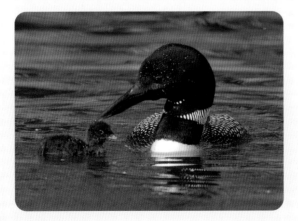

For the first few days of life, chicks are fed tiny fish caught by their parents. One adult stays on the surface of the water while the other dives for food.

During the first few weeks of life, females stay with the young. While males spend more time with the young when they get older, it is the females that are the primary attendants overall.

Loon adults adopt the young of other loons if needed and when there's enough food. This behavior is uncommon since it is rare for both parents to die and leave a chick on its own.

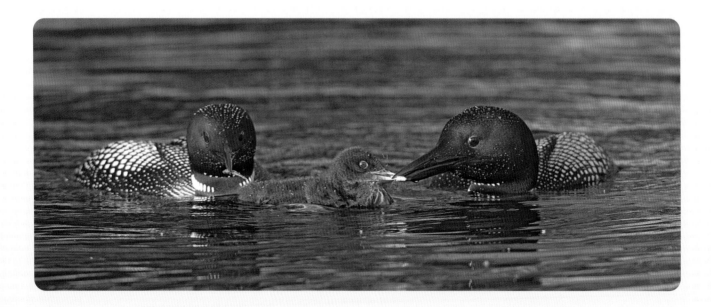

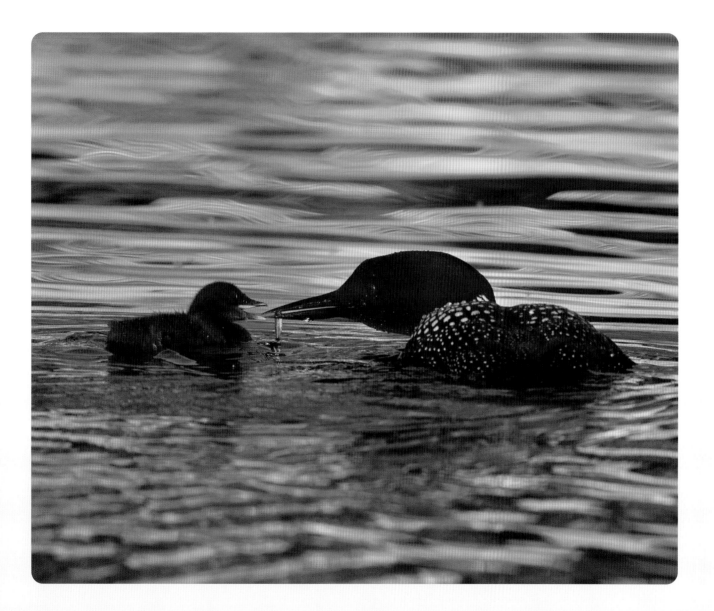

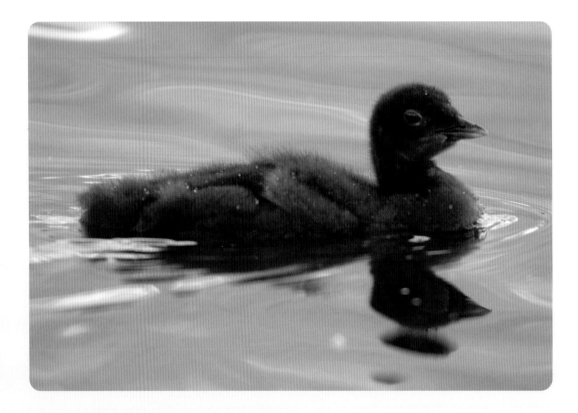

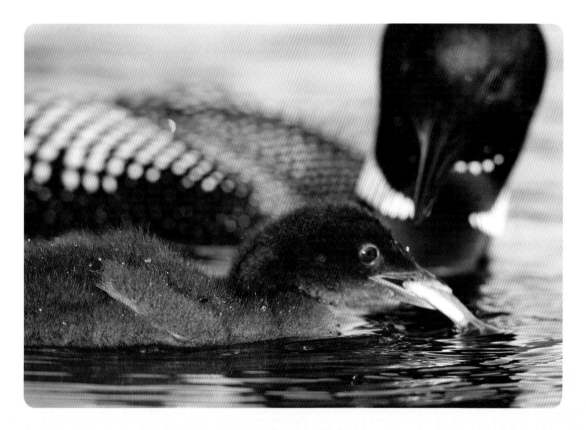

Feathers of newly hatched loons dry within hours after chicks hatch. Young loons have two plumages. Newly hatched chicks have dark brown-to-black feathers and white-feathered bellies. When chicks are 10-14 days of age, the dark feathers are replaced by brownish gray downy feathers (see above). At 10-11 weeks, the down feathers are replaced by juvenile contour feathers.

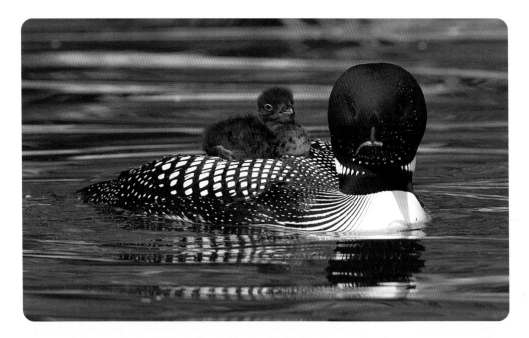

During the first seven days of life, chicks ride safely on the backs of their parents. Predators such as Northern Pike, Muskie and Snapping Turtles are a constant threat to tiny loons. Resting on the back of a parent greatly reduces exposure to these dangers.

The young ask to ride by nudging a parent along its side. The parent responds by raising a wing slightly, allowing the chick to maneuver underneath and rest on the adult's back. A parent's wings can either completely cover and shield the young, or the young can rest openly on the parent's back.

By the eighth day, the time spent riding on parents drops dramatically. Most likely this change in behavior is due to the increasing size of the chick, not the intolerance of the adult. Most chicks stop back riding at 2-3 weeks of age. A chick that is too large for back riding will tuck its head under the parent's wing. After the chick falls asleep, the parent swims off, towing the young in a headlock embrace.

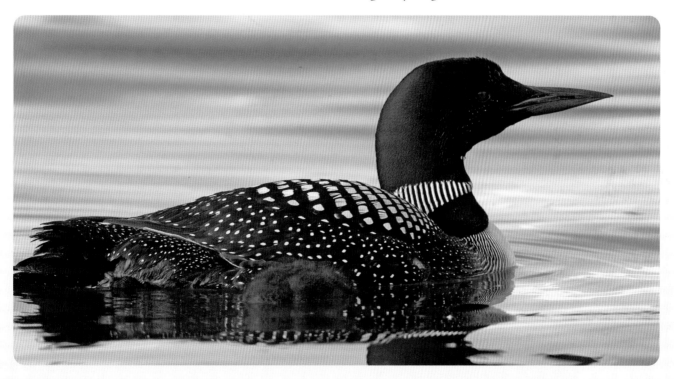

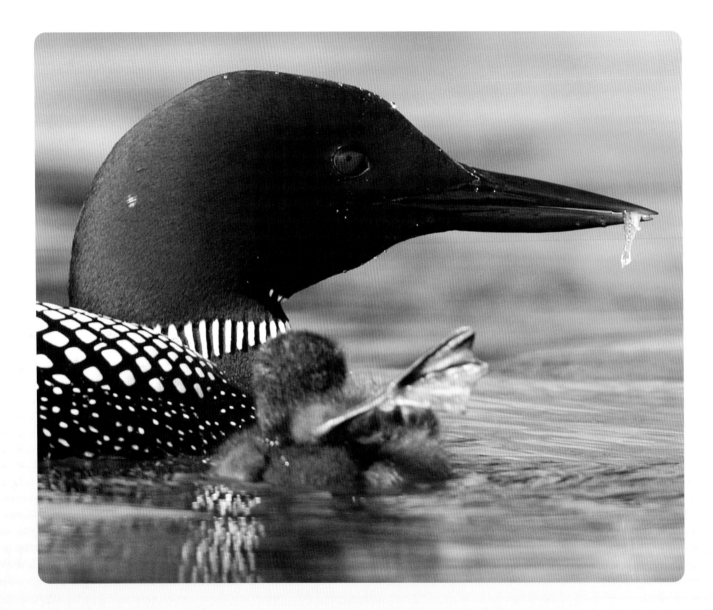

One-day-old chicks dive for 1-2 seconds and pop back to the surface like corks. They also foot waggle on their first day of life. By the second day, they start to preen, scratch and tuck their heads under their wings to sleep. At 3 days of age, chicks start performing wing stretches.

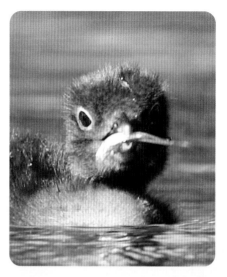

By the fourth day of life, chicks have enough feathers and body fat to regulate body temperature (thermoregulation). This allows them to spend more time in cold water and less time riding on their parents. At four days, baby loons dip their bills into the water to preen. Five days after hatching, young loons begin to dive and make underwater turns.

By 8 weeks of age, loon chicks are meeting up to half of their dietary needs on their own, usually with small fish. At this age they can be left alone for short periods of time.

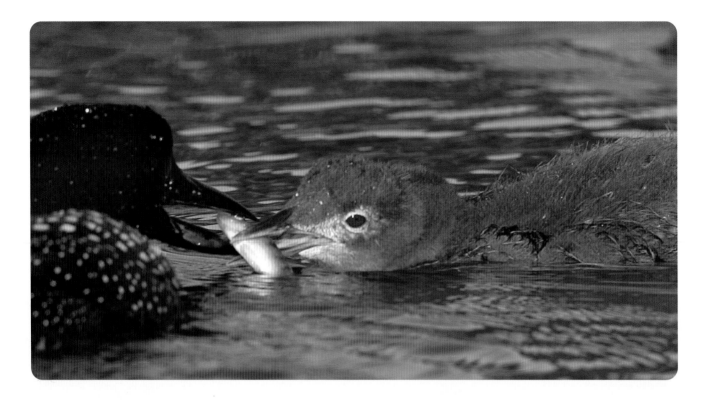

While adults use only their feet for propulsion, small chicks use their feet and wings for underwater locomotion. Chicks gradually change to feet-only propulsion as they grow.

At the end of their first winter, juvenile loons molt to a basic gray and white plumage. In the process, they lose many of their primary and secondary flight feathers, rendering them nearly flightless.

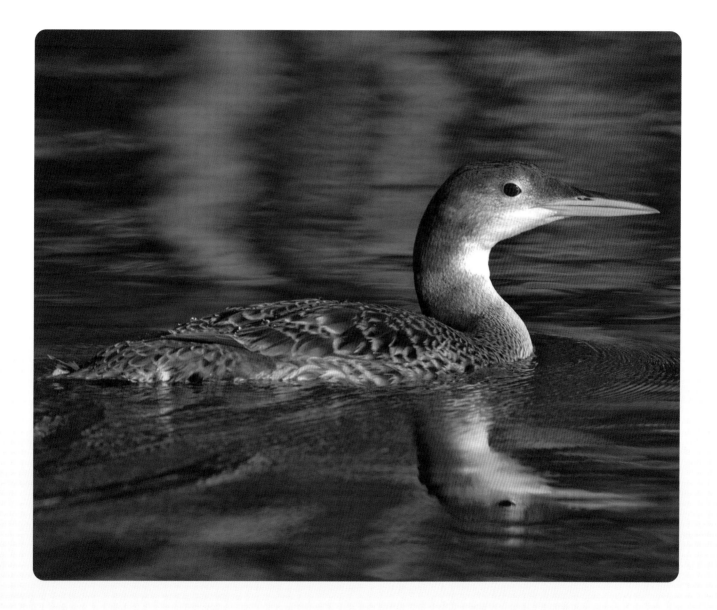

Loons gather in large migration groups during late summer and early fall, but migrate individually. Adults leave in autumn a few days to several weeks before the young. Loons migrate anytime during the day and rarely at night. Most leave at first light before the sun comes up and fly throughout the day, landing just before it gets dark after sunset.

Differences between autumn migration groups and social gatherings include time of year, activities and group size. Autumn migration groups may include juveniles, while social gatherings do not. Surveys on important staging lakes such as Lake Mille Lacs in Minnesota show that just before autumn migration, loons gather in very large groups of up to 5,000 adults and juveniles.

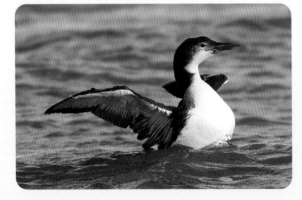

During migration, loons take a day to a week to rest and feed. Recent studies show that birds migrating out of the upper Midwest stop at Lake Michigan for a few days before heading toward the southern states, where they rest and feed at large reservoirs. While most loons in the central part of North America around the Great Lakes region migrate to the Gulf of Mexico to spend the winter, some winter along the eastern coast of Florida. Loons in eastern states usually winter along the Atlantic coast from the Carolinas to Florida.

Migrating loons fly at high speeds ranging from 75-110 mph (120-175 km/h) and at elevations between 4,900-8,800 feet (1,500-2,700 m). Flying at higher elevations means less air density, which adds about 10 percent to flight speed. In addition, there is less air turbulence at high elevations due to laminar winds (smooth, stratified or flat air flow), and the air is cooler, which helps to decrease overheating or heat stress of loons.

Due to prevailing winds from the west and northwest, migration speeds are on average faster during fall migration than in spring. Loons average about 105 mph (170 km/h) in fall. Since they often fly into headwinds on their return, the average speed in spring is reduced to about 90 mph (145 km/h).

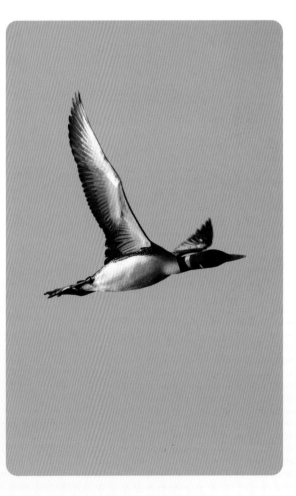

Toward the end of winter, adult loons migrate north to nest and raise another brood. Immature birds do not return to their natal lake because they are molting and temporarily unable to fly long distances. The absence of 1-year-old non-breeding birds in the area is beneficial to mated pairs because it reduces the competition for food.

One-year-old birds stay on coastal waters during summer and remain there until they are 2-3 years old. Occasionally 2-year-old birds return to the breeding lakes, but they are often driven off by resident loons, usually their parents. The majority of birds that return to breed are 3-5 years of age.

Male and female loons arrive on their breeding lake at the same time each spring. Mated pairs usually return to the same lake for many successive years.

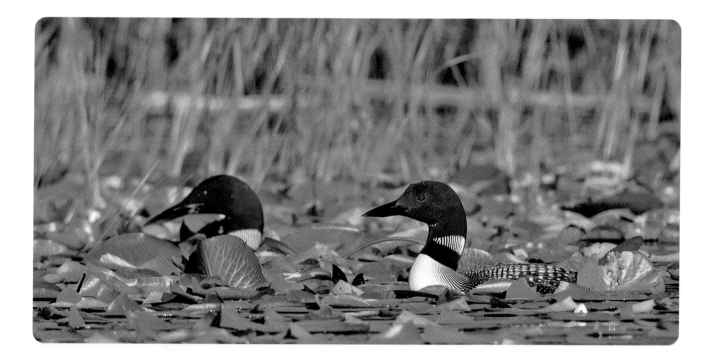

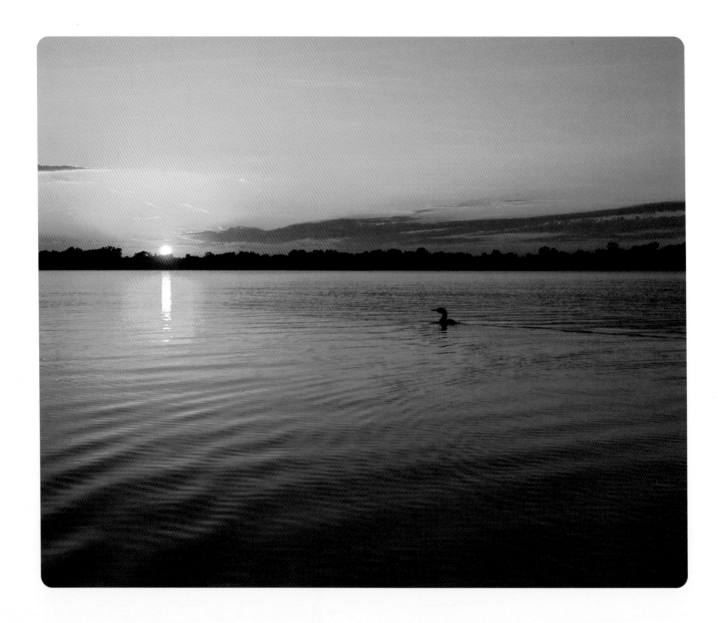

With the arrival of the loons each spring on their lakes, the season starts anew. Just as they have done for thousands of years, loon adults establish or re-establish the pair bond and get to the business of choosing a nest site, constructing a nest, incubating eggs and attending to the needs of the young. It is a natural cycle of life that brings a certain comfort and calm to my world. I have spent countless hours watching and photographing loons feeding and caring for their young, and I am comfortable saying you would be hard pressed to find a more loving, attentive bird parent than a loon. They are gentle and patient with their babies, yet find time to socialize with other adult loons. They are extremely good-looking birds with many highly specialized adaptations, making them unlike many other birds. Their calls have become a calling card for true wilderness. They have survived an ever-changing environment and seem to be adapting to excessive encroachment by humans. They are an endearing bird that has captured the hearts of people at their lakes, fascinating us now as they have for thousands of years.

ABOUT THE AUTHOR

Stan Tekiela is a naturalist, author and wildlife photographer with a Bachelor of Science degree in Natural History from the University of Minnesota. He has been a professional naturalist for more than 20 years and is a member of the Minnesota Naturalist Association, Minnesota Ornithologist Union, Outdoor Writers Association of America, North American Nature Photography Association and Canon Professional Services. Stan actively studies and photographs birds and wildlife throughout the United States. He has received various national and regional awards for outdoor education and writing. A columnist and radio personality, his syndicated column appears in over 20 cities and he can be heard on a number of radio stations. Stan lives in Victoria, Minnesota, with wife Katherine and daughter Abigail. He can be contacted via his web page at www.naturesmart.com.

Stan authors other nature books including field guides for birds, birds of prey, mammals, reptiles and amphibians, trees and wildflowers.